IMAGES
of America

MOUNT PROSPECT
HISTORIC SITES

IMAGES
of America

MOUNT PROSPECT
HISTORIC SITES

Emily A. Dattilo

ARCADIA
PUBLISHING

Copyright © 2023 by Emily A. Dattilo
ISBN 978-1-4671-6008-7

Published by Arcadia Publishing
Charleston, South Carolina

Printed in the United States of America

Library of Congress Control Number: 2023931695

For all general information, please contact Arcadia Publishing:
Telephone 843-853-2070
Fax 843-853-0044
E-mail sales@arcadiapublishing.com
For customer service and orders:
Toll-Free 1-888-313-2665

Visit us on the Internet at www.arcadiapublishing.com

To Mom and Dad, my biggest fans

CONTENTS

Acknowledgments 6

Introduction 7

1. Success Stories 9

2. Hidden in Plain Sight 39

3. Bits and Pieces 75

4. Collective Memory 103

Index 127

Acknowledgments

It "takes a village" to write a book, and I have been very lucky to find support in and around the village of Mount Prospect. First, thank you to the Mount Prospect Historical Society Board of Directors, especially the Executive Board, for allowing me to tackle this project.

I am immensely grateful for the friendship and support of my coworker Amanda Marcus. Her assistance with brainstorming and research and generally keeping me grounded has been invaluable.

Thank you to Amy Jarvis, my title manager at Arcadia Publishing, for guiding me through the process of writing my first book.

I sincerely appreciate the assistance I received from members of the community. Anne Shaughnessy, librarian at the Mount Prospect Public Library, not only helped me with research but also shared her digitization expertise to ensure that all the photographs in this book were the best possible quality.

Laura Stamison, administrative assistant in the Mount Prospect School District 57 Department of Teaching and Learning, generously found and lent me what is possibly the only existing photograph of Gregory School.

Michael Stachnik at the Elk Grove Historical Museum went the extra mile to find high-quality photographs of the United Airlines headquarters.

Mount Prospect village clerk Karen Agoranos dug into the Village of Mount Prospect's records to answer some of my history mysteries.

Mount Prospect Historical Society volunteers Dodie Frisbie, Diane Lembesis, and Mark Thoms assisted me with researching several of the historic sites discussed in this book. Dana Carr helped to create the index.

I appreciate Jean Murphy's editing skills and her tenacity in tracking down some of the most well-hidden photographs of local historic sites. This book would be much shorter without her help and encyclopedic knowledge of the community.

Thank you to Deb Rittle for planting the idea that blossomed into this book.

Finally, thank you to my family—Roxanne, Tom, David, and Lex—and my friends for all their support during this project and throughout my career.

Unless otherwise noted, all images appear courtesy of the Mount Prospect Historical Society.

INTRODUCTION

People have lived for centuries in what is now Mount Prospect, Illinois, but the area's history is rarely obvious at a glance. Mount Prospect has changed considerably since it incorporated as a village in February 1917, and the change continues to this day. The past 100 years have been especially transformative, because events within that span of time transformed the town from a farming community to a growing suburb of Chicago. As a result, every generation has come to know a different version of the town.

Not long after Mount Prospect's incorporation in 1917, it began to attract developers who subdivided farmland into residential neighborhoods. The semirural setting of these new developments attracted many newcomers, creating Mount Prospect's first population boom. Local leaders responded by upgrading the country town with paved roads, indoor plumbing, and new commercial buildings— to name a few improvements. Increasing numbers of school-age children also necessitated the construction of the second Central School to replace the town's first one-room schoolhouse. All of these local projects, as well as the population boom, attracted the attention of *Real Estate News*, a Chicago real estate journal. The September 1927 issue of *Real Estate News* praised Mount Prospect's political and business leaders for their investment in the community and highlighted all the desirable features of the town, from the paved streets to the ample business opportunities. In one article, Mount Prospect is labeled the "City of Progress." By the beginning of the Great Depression in 1929, Mount Prospect was already a vastly different town from the one that had barely reached the population requirement for incorporation as a village nearly 10 years earlier.

The Great Depression and the United States' entry into World War II shifted local and national priorities away from home front improvements for nearly 20 years. The end of the war, however, brought local concerns back to the forefront as people swarmed to towns just outside major cities. The population grew even more dramatically than it had during the first boom of the 1920s. Mount Prospect was one of many small rural towns across the United States that transformed into suburbs during the 1950s and 1960s because of this influx of new residents. Just like in the 1920s, local leaders invested in the town's infrastructure to accommodate so many newcomers. This time, though, the transformations were more radical and more widespread. Within this short stretch of time, seven public grade schools and a public high school were built. Civic improvements like the first purpose-built freestanding municipal building and public library demonstrated the community's efforts to modernize public services. Developers replaced remaining farmland with housing developments and massive shopping centers at the edge of town, like Randhurst and Mount Prospect Plaza. These new, innovative places became stiff competition for long-established businesses in the downtown area. By the time the nearly two decades of fast-paced growth slowed in the 1970s, a new, suburban Mount Prospect appeared to have replaced the small rural town it once was. Even the town's motto had to be adapted—in 1965, it changed from "where town and country meet" to "where friendliness is a way of life."

These and other transformations later in the 20th century dramatically changed the local landscape and, in a sense, made it what it is today. Much of Mount Prospect's visible history in 2023 is the product of post–World War II expansions and redevelopment projects, with some older structures scattered around town. For that matter, there are plenty of new development projects planned for the future.

Despite appearances, not all of Mount Prospect's history has been lost. The changes themselves are part of local history and have simply made older history more challenging to locate. Each addition or demolition in town contributes to the overall story of Mount Prospect and can show historians, as well as residents, how the town responded to changes in the world.

Mount Prospect Historic Sites explores the many pieces of local history that are still visible in town, from celebrated historic buildings to places that have disappeared from the landscape but live on in local memories. The first chapter, "Success Stories," focuses on preserved historic sites and buildings, especially those that are well known. While some places have been home to popular businesses—like Mrs. P & Me—for a long time, other sites remain intact because of extensive community efforts. The Mount Prospect Historical Society's Dietrich Friedrichs House and one-room Central School are two such examples.

The second chapter, "Hidden in Plain Sight," highlights places in Mount Prospect that can sometimes be overlooked for a variety of reasons. Most of the sites in this chapter are relatively recent additions to the local landscape or simply appear too ordinary to be considered historic. The Veterans of Foreign Wars Hall on Main Street is an excellent example of both considerations. It was constructed in the 1950s, a time that is still within living memory for many residents, and was intentionally designed to blend in with the ranch-style homes around it.

The chapter titled "Bits and Pieces" discusses local historic structures that are no longer standing but have remnants that have made their way into the historical society's artifact collection. These serve as the last remaining physical connections to those historic sites. Ties to the past are especially important in cases like the Main Street Busse buildings, which were unexpectedly destroyed in a 2014 fire. The destruction of these historic structures in the center of the downtown business community left a physical and metaphorical hole in the landscape.

Finally, the chapter titled "Collective Memories" shares sites that have minimal or no remaining physical presence but still hold a cherished place in residents' memories. For instance, Mount Prospect's historic downtown, known as the "Small Triangle," has undergone extensive redevelopment in the past 20 years, making the area unrecognizable to past generations. Restaurants like Sammy Skobel's Hot Dogs Plus and the Hapsburg Inn still have devoted fans even though the restaurants closed decades ago. It is impossible to include all of the sites that residents hold dear, but this book aims to include places that could be properly represented with available images.

One

SUCCESS STORIES

Despite the ever-changing cycle of development and redevelopment, there are still historic buildings in Mount Prospect. Some have been saved from the wrecking ball by community action, like the one-room Central School and the Moehling General Store building, while others have quietly served the community in more or less the same way as originally intended, like Mrs. P & Me. All in all, the buildings in this chapter stand as a testament to their continuing importance in the community.

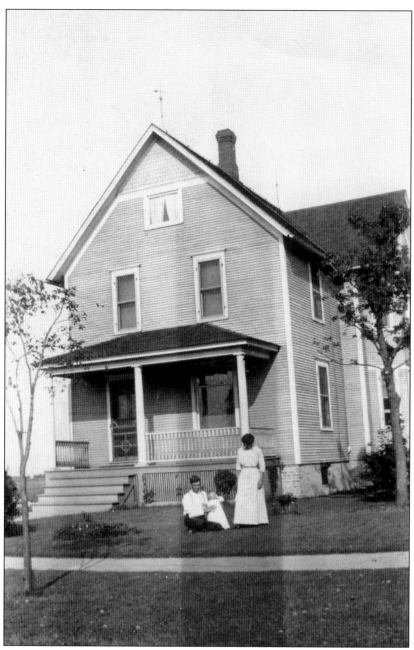

In 1906, Dietrich and Lena Friedrichs, a newly married German American couple, constructed the house at 101 South Maple Street. Their home was only the 13th house in Mount Prospect, which was then a small rural community of German immigrants and their descendants. This photograph shows Dietrich, Lena, and their baby daughter Bessie on the front lawn around 1912, before the house's front porch was enclosed. Unlike most of his neighbors, Dietrich was not a farmer; he was a house painter. Consequently, he took great pride in maintaining his home's pristine white paint job, which also served to advertise his business. The Friedrichs remodeled their family home in the 1920s, enclosing the front porch and expanding the parlor. Dietrich and Lena stayed at 101 South Maple Street for the rest of their lives, and Bessie lived there for most of her adult life.

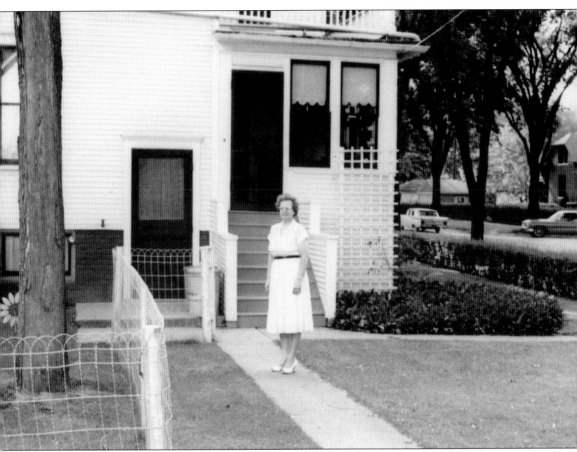

By 1966, Dietrich and Lena Friedrichs had passed away, and their daughter Bessie wanted to move into a home of her own with her second husband, Charles Barnes, so she sold the house at 101 South Maple Street to Richard and Jane Webb and moved to another house in Mount Prospect. In 1961, an unidentified photographer captured this picture of Bessie outside the back door of her childhood home. The Webbs redecorated the house and added a bathroom on the main level. In 1975, the Webbs sold the house to their neighbor across Maple Street—First Chicago Bank of Mount Prospect. This bank originally planned to pave a parking lot on the site, but the Village of Mount Prospect Board of Trustees rejected that proposal. First Chicago Bank instead rented the house to various tenants during the 1980s. One memorable resident had a cat with kittens, and the kittens roamed throughout the house!

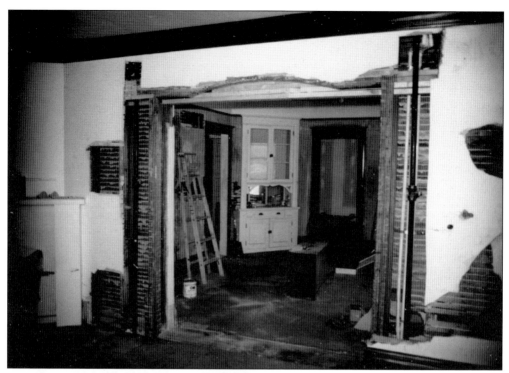

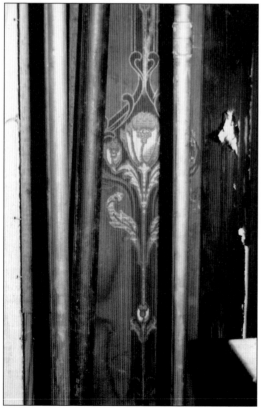

First Chicago Bank decided to put the house at 101 South Maple Street up for sale in 1987. First, the bank approached the Village of Mount Prospect with an offer, so the village turned to the Mount Prospect Historical Society. The historical society then began an intense fund-raising campaign to purchase the house. After raising enough money to purchase the historic house, the historical society continued raising funds to cover the costs of repairing and restoring it. One of the restoration projects was returning the pocket doors to the parlor and dining room doorway, as shown in the March 1992 photograph above. The team also discovered remnants of past wallpaper hidden within the walls, such as the bold floral design along the staircase pictured at left.

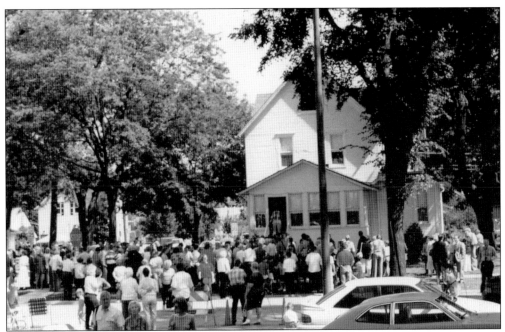

The Mount Prospect Historical Society's hard work and determination paid off with the official opening of the Dietrich Friedrichs House Museum on September 12, 1992. Crowds gathered on the front lawn and in the streets to attend the ceremony and take tours. The Dietrich Friedrichs House continues to remain open as a museum and also houses the historical society's office.

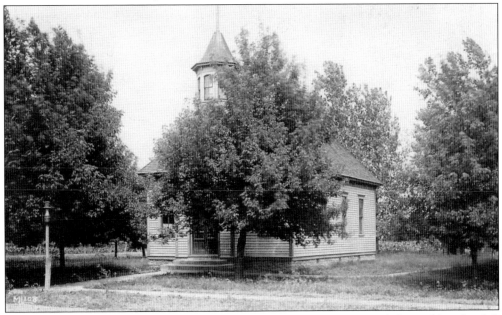

Central School, pictured here during the early 1900s, was Mount Prospect's first public school. It was constructed in 1896 by William Wille on land that William Busse donated near the corner of Central Road and Main Street. Central School became an important community space for both students and adults. Many institutions and organizations were founded there, including the fire department, St. Paul Lutheran Church, the library, and the village itself.

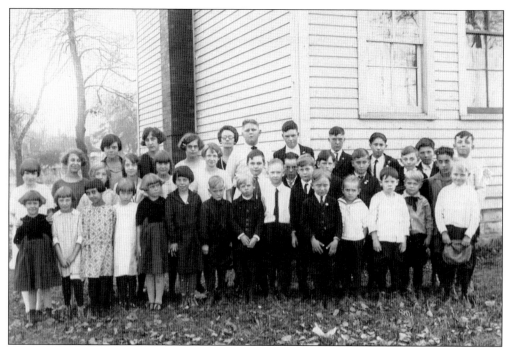

Central School was typical of many rural schools established during the 19th century in that it consisted of only one room. Isabel Butler, the teacher shown in this 1923 class photograph, would have educated students in grades one through eight in her classroom. They learned the three Rs (reading, writing, and arithmetic), as well as whatever other subjects the instructor was knowledgeable enough about to teach.

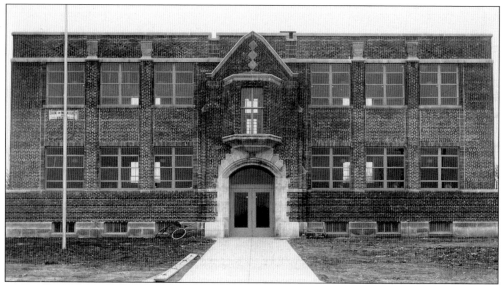

Mount Prospect grew out of the one-room schoolhouse by the 1920s, so a second Central School was constructed next to the original building in 1927. This new building, designed by architects Zook and McCaughey, had two floors and four classrooms. In this image, the structure stands completed but in need of landscaping.

Generations of students graduated from the second Central School between its completion in 1927 and when it was demolished in 1975. Even after it was no longer the only public grade school in town, for many residents, it was an essential part of growing up in Mount Prospect. Pictured here is the graduating class of 1938.

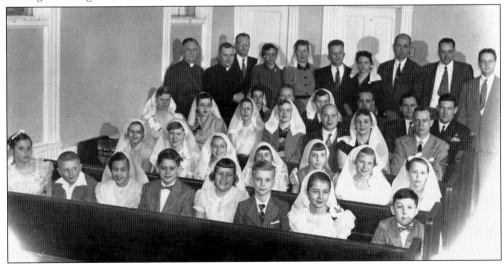

In 1937, St. John's Episcopal Church purchased and moved the one-room Central School to the corner of Thayer and Wille Streets, and the school building became the congregation's sanctuary. The confirmation candidates pictured here paused for a photograph inside the sanctuary, probably during the early 1950s. The congregation grew over the years and constructed a new church building in 1954. The Central School building was converted for use as offices and Sunday school classrooms.

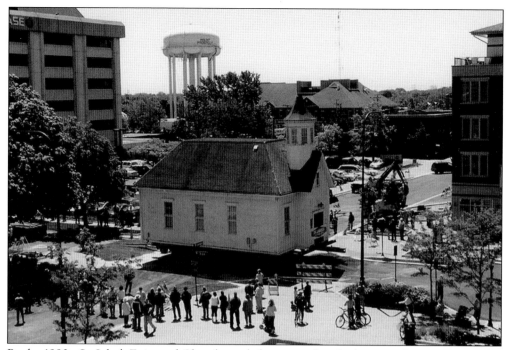

By the 1990s, St. John's Episcopal Church needed to expand its facilities, so the Mount Prospect Historical Society purchased the one-room Central School in 2002. The historical society paid $1 for it and agreed to move the structure. On May 28, 2008, Central School was finally moved across town to the historical society campus on South Maple Street. In the moving day photograph above, the building is at Busse Avenue and Emerson Street. The historical society spent the next nine years fund-raising for the restoration, and the work was finally completed in 2017—just in time to celebrate Mount Prospect's 100th anniversary inside this historic building. Today, the historical society hosts various educational programs in the previous school, making it once again a space for the community to enjoy. The below image, from June 2022, shows students at History Camp listening intently as the teacher writes the next lesson on the chalkboard during an 1896 Living History program.

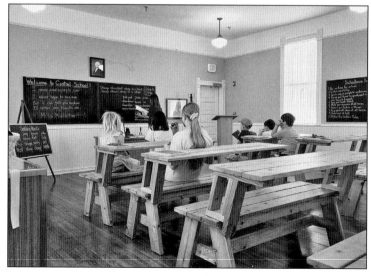

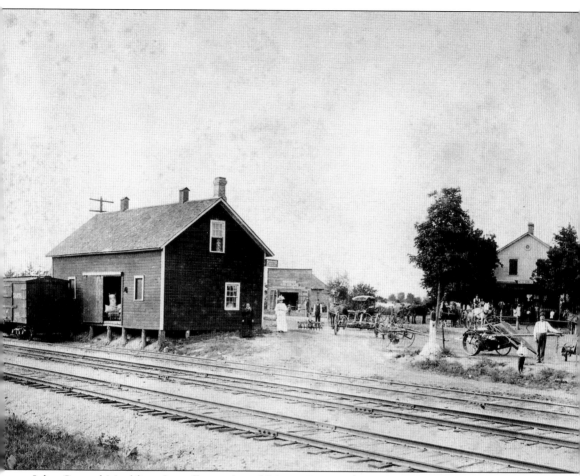

John Conrad Moehling formally purchased Mount Prospect's first general store in 1882 from Christian Geils, a Cook County commissioner. The building originally stood on the northeast corner of Northwest Highway and Main Street and was conveniently located near the train station. Moehling added farm supplies to the store's offerings and established the town's first post office there. This photograph, taken some time after 1885, captures a busy moment in the heart of town and demonstrates Moehling's importance in the community, as he was responsible for establishing every building in the photograph. His general store is on the right with a "Post Office" sign on the awning. Moehling and his son, John Philip, are standing in the foreground directly in front of the store. The warehouse on the left was used for shipping merchandise and farm goods in and out of town. Moehling also brought the first blacksmith to town, and his forge is in the building in the background.

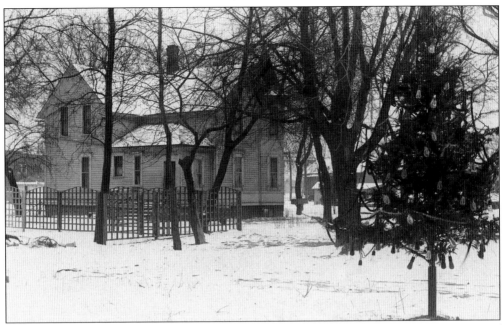

In the 1890s, John Conrad Moehling built the home in this photograph, and four generations of Moehlings called it home. It is pictured above with Mount Prospect's Christmas tree in the 1920s. Although the Moehling family home was demolished in 1966, each of John Conrad's descendants left a lasting mark on the town. His son, John Philip, opened one of the first service stations in town in 1927, and his granddaughter, Gertrude Francek, was an active businesswoman. Gertrude also cofounded the Mount Prospect Historical Society in 1968. She is shown in the photograph below with four of the historical society's other founding ladies. Pictured here are, from left to right, (first row) Meta Bittner and Doris Weber Norris; (second row) Dolores Haugh, Gertrude Francek, and Edith Freund.

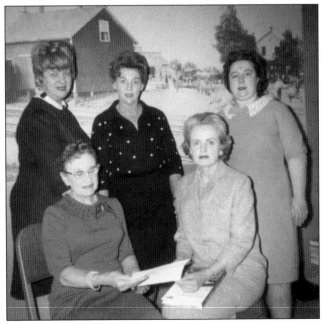

Several businesses came and went in the former general store building on Northwest Highway and Main Street over the years, including Moehling's Ice Cream Parlor in the 1930s, V and G Printers in the 1940s, and Jim Faetz's State Farm Insurance office in the 1960s. One of the most memorable occupants was Hotter Than Mother's Music. This record store opened in 1970 or 1971 and received approval from the village to add pinball machines in 1975. This photograph shows the building in 1977. Music lovers and pinball players came from the surrounding suburbs to browse the shelves and spend some quarters. In 1977, the players put their quarters toward a good cause as part of Johnnie May Day. The manager of Hotter Than Mother Music's, Bill Herman, coordinated a fund-raiser to raise money to buy a pinball machine for Johnnie May, an avid pinball player living with cystic fibrosis. Hotter Than Mother's Music closed in the 1980s and was replaced by Keyser Chiropractic in the 1990s.

By the late 1990s, the town's oldest commercial building, at Northwest Highway and Main Street, was dilapidated and in the way of downtown development projects. Community members, led by Village of Mount Prospect trustee Paul Hoefert, united to save the historic structure and move it to 10 South Pine Street, as shown in this 1999 photograph. Vocational students from High School District 214 did much of the rehabilitation work to prepare it for a new business, Capannari's Ice Cream.

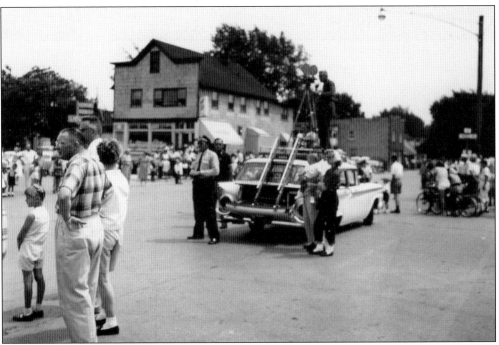

Residents and travelers alike have found good meals at 100 East Prospect Avenue. In 1902, Henry Behrens Jr. opened a tavern here, but he switched to selling "near beer" and soda during Prohibition. In 1923, Behrens sold the establishment to William and Sophie Kruse. Kruse's Tavern is visible in the background of this photograph of the 1959 Fourth of July parade. At that point, the building had undergone few significant exterior renovations.

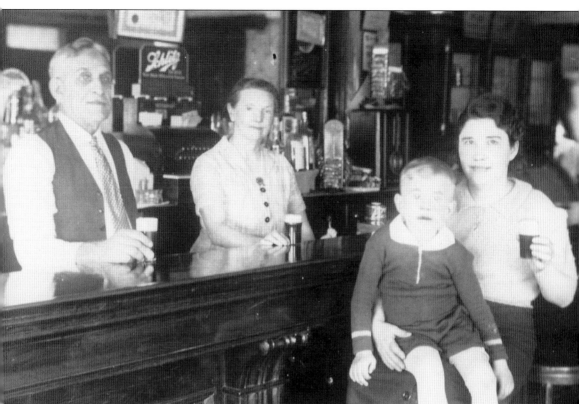

Kruse's Tavern was a gathering place for Mount Prospect residents, and in turn, the Kruse family was active in town. For instance, one of William and Sophie Kruse's sons, Rudolph, was a founding member of the Mount Prospect Chamber of Commerce. The organization was established at a table in the restaurant on October 12, 1926. Another Kruse son, Henry, participated in the Lions Club. One major club project led to the installation of street signs around town. The Kruses returned to selling alcohol after the repeal of Prohibition in 1933, further cementing their important place in the community. They reopened the bar and equipped the restaurant with oak back bar cabinets and an oak beer cooler to prepare for the new beverage menu. In this photograph, William and Sophie stand behind the bar, while one of the Kruse daughters and a grandson are seated at the bar.

William and Sophie Kruse expanded and remodeled Kruse's Tavern at various points during their ownership of the building. In 1962, they added Tudor-style timber frames to the exterior. In 1973, they sold the business to new owners who later opened Pier 100, a seafood restaurant. The Tudor facade with a Pier 100 sign is visible in the background of this 1976 parade photograph.

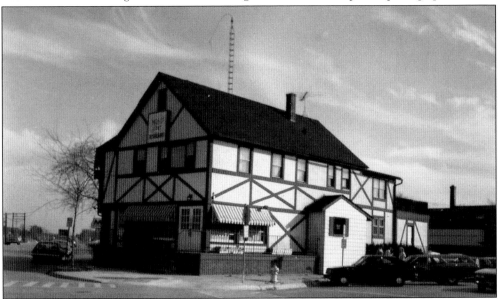

Pier 100 closed in 1977 and was replaced by Dennis and Mary Lynn Miller's restaurant, Mrs. P & Me. The letter "P" stands for Pittsburgh, Dennis's hometown. The couple continued the tradition of hospitality in the community, and now three owners, all Mount Prospect residents, do the same. This photograph was taken in the 1980s, but the historic structure still looks similar today.

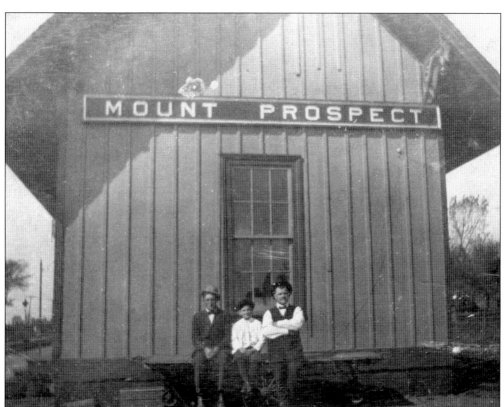

Mount Prospect's first developer, Ezra Eggleston, built a train station shortly after purchasing 140 acres of land in 1874. He correctly believed that access to the train would help the new town thrive. Farmers relied on the train to ship goods to Chicago, where they would be sold and distributed across the country. In this undated postcard photograph, cousins Emil Greimke and May and Herman Pallas sit outside Eggleston's original station.

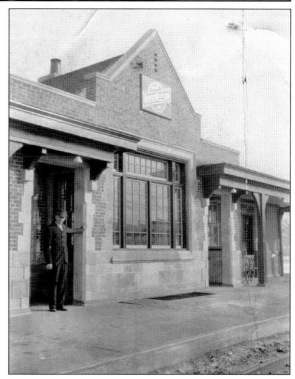

Mount Prospect's tiny train station was replaced with a grander one in 1930 thanks to new resident Ben Terpning, who was the general superintendent of the Chicago & North Western Railway system and saw firsthand that the station needed an upgrade. This photograph shows station master John Pohlman standing in uniform outside the new station during the 1930s. Pohlman served as stationmaster for 43 years.

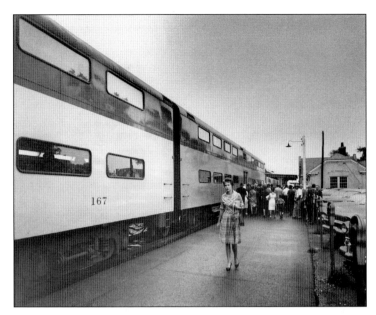

When Mount Prospect's population exploded in the 1950s and 1960s, the community's relationship to the train changed, too. Many of the new suburban residents worked in Chicago and rode the train to and from work each day. Before long, there were more commuters than farm products heading to Chicago on the train! In this photograph from the 1950s or 1960s, a crowd is waiting to board the train.

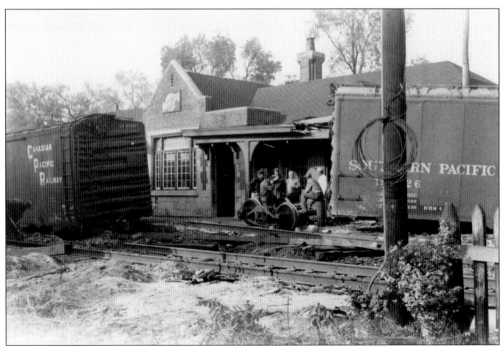

One of the biggest train disasters in local history happened in the early hours of October 21, 1959. A hot bearing box caused a freight train hauling 24 cars to derail near the Mount Prospect station. No one was injured, but the station was damaged. A chunk of the platform's roof is missing in this photograph of the cleanup efforts, and the train car is still leaning on the damaged section.

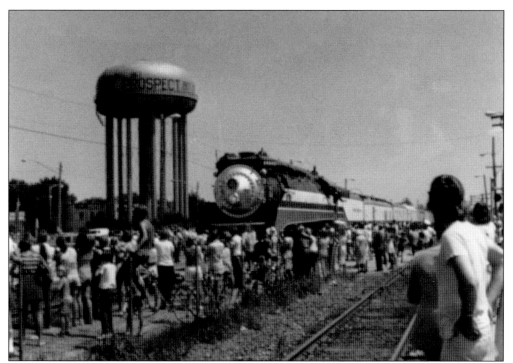

The American Freedom Train arrived on August 4, 1975, as part of an early local event to celebrate the nation's bicentennial. Residents packed the train station to watch the train pass through town and peek at the cars displaying the history of the United States. Here, crowds line the tracks as the locomotive approaches, and the water tower, a local landmark, stands in the background.

The Mount Prospect train station has undergone renovations over the years, but it remains essentially the same station that has served the community since 1930, as shown in this 1990 photograph by Budd Wilder. The station has become a community center by offering space to local businesses, like Al's Shoe Service, and hosting the Lions Club Farmers Market in the commuter parking lot throughout the summer and fall.

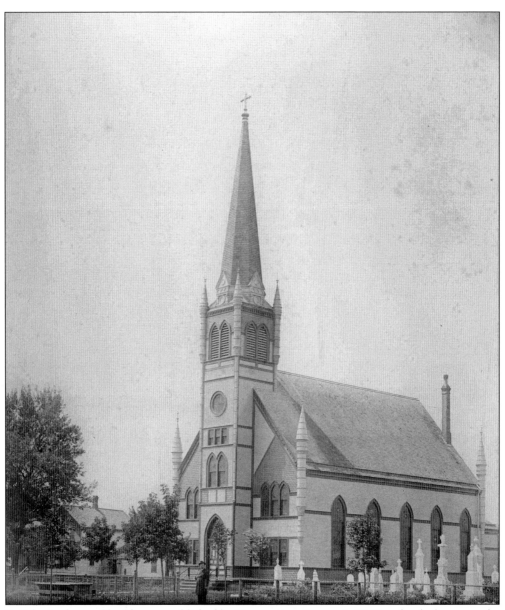

St. John Lutheran Church was established by German immigrants in 1848 on land adjacent to the Linnemann family farm. A cemetery was established on the church grounds a few years later. St. John was the first church in what is now Mount Prospect. Services were held in German, which allowed the new members of the community to preserve their religious and cultural traditions in their new home. A shared religion and culture helped bond this early farming community. Many descendants from the founding families later helped incorporate the Village of Mount Prospect in 1917. The church pictured in this early-20th-century photograph is the third permanent church building, which was completed in 1892. The cemetery is visible at lower right. The first church building (from 1848) was a rugged, temporary structure; the first permanent building, completed a few years later, was destroyed by a fire in the 1850s and replaced soon afterward by the second permanent building.

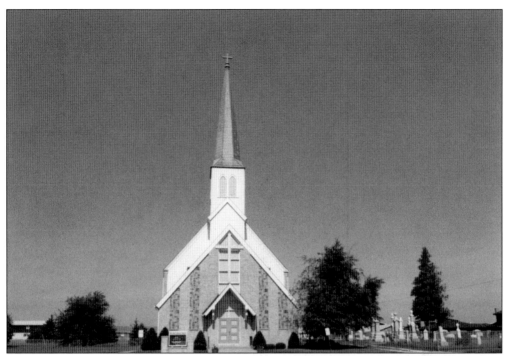

The 1892 church continues to serve the congregation at St. John Lutheran Church, although the structure has undergone several modifications and additions. The current church is pictured in July 1974 with the cemetery on the right. The congregation has also adapted to changing times. January 1960 was the last time a regular service was held in German, and in 1970, the property became part of Mount Prospect.

The steeple of St. John Lutheran Church is not original to the 1892 structure; the original steeple was knocked down during a violent storm in the spring of 1979. This photograph shows the damaged building after the debris had been cleaned up. It took the congregation approximately a year and a half to raise sufficient funds to replace the steeple.

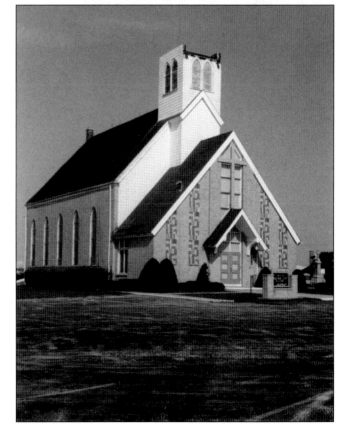

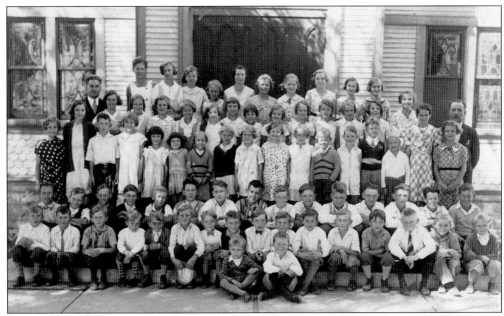

The founding families of St. John Lutheran Church established a school not long after organizing the church in 1848. Many children of area farmers and business owners attended classes here. This class photograph from 1934 includes children from the Linnemann, Busse, Wille, Moehling, and Moellenkamp families. Over the following decades, students attended classes in several structures, including the original church building. The first purpose-built school was constructed in 1864, and a larger school was added to the church grounds in 1901. The 1901 school had just one classroom until a remodel in 1926 added another classroom and restrooms. The children in the 1940s photograph below are seated in that remodeled building. A larger school was completed in 1959 and used until the school closed in 2004.

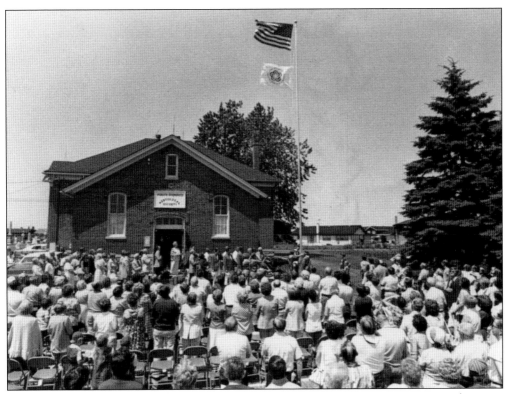

The congregation of St. John Lutheran Church allowed the Mount Prospect Historical Society to move into the church's 1901 school building in 1974. This was the historical society's first permanent home. Two years later, on July 3, 1976, crowds gathered to celebrate the new museum and local history at a Bicentennial Dedication Ceremony (pictured above). One clear advantage of the new space was the ample room it offered for both public exhibits and the safe storage of artifacts; previously, historical society members had stored artifacts in their own homes. The earliest exhibits contained displays of local history and scenes depicting life in the early 1900s, like this corner (pictured below) that featured a one-room schoolhouse classroom.

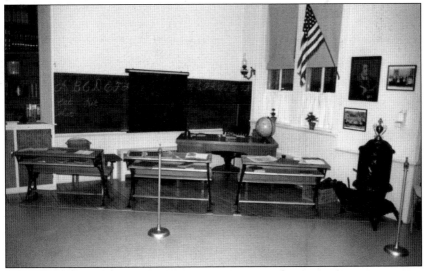

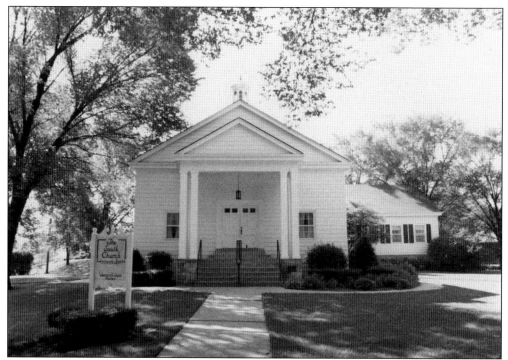

The first services for the South Church Community Baptist congregation were held in February 1937 at the Veterans of Foreign Wars Hall and the Mount Prospect Country Club. This congregation belonged to the first non-Lutheran church in town. The church building was constructed and dedicated in December of that year, just in time for Christmas. This July 1974 photograph shows the original building with an addition in the back.

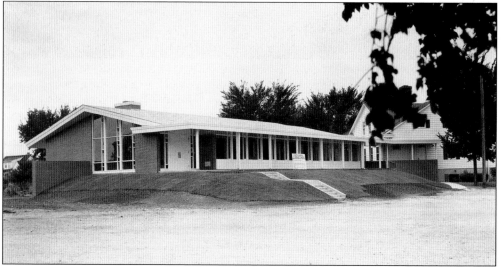

In just over 10 years, South Church Community Baptist outgrew its first building. A chapel, pastor's study, and classrooms were added to the back of the original building in 1950, and construction was completed on the education building (pictured) in 1958. In later years, the church added stained-glass windows and a memorial garden. The church sold the building to another congregation in 2017 but continued to hold services there.

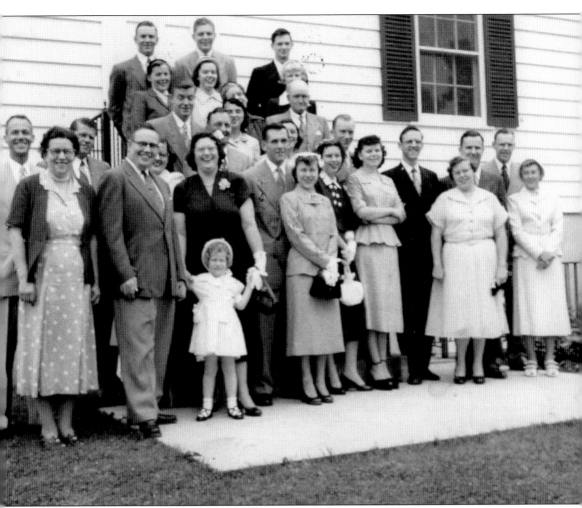

Pastor Edwin Stevens of South Church Community Baptist formed the Young Married Couples (YOMARCOS) group in 1947 after noticing that local young couples were searching for inexpensive social gatherings and a sense of community. YOMARCOS fulfilled both of these needs and was open to married couples of any faith. Initially, YOMARCOS members had to be under 35 years old, but that requirement was dropped in 1952, "provided [members] are young at heart," according to Pastor Stevens. This fun-loving group regularly hosted events and speakers, planned outings, and organized charity work. The potluck dinners were highlights of the YOMARCOS calendar. Each month from October through April, members took turns cooking dishes on a themed menu, which could feature anything from German cuisine to seafood. Early YOMARCOS members posed for this undated group photograph outside the church. The group celebrated its 50th anniversary in 1997.

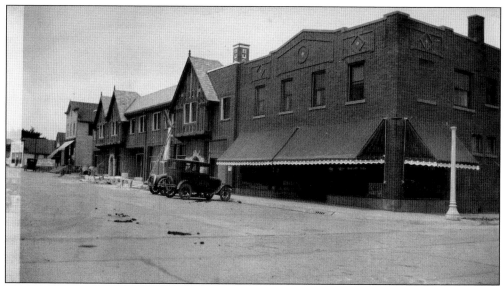

Members of the Busse family commissioned the construction of a large commercial building on West Busse Avenue between William Busse Sr.'s hardware store and Wille's Tavern. Construction was nearly completed at the time of this July 1927 photograph. This brick building had a Tudor-style facade that matched the structure that William Busse Jr. was building on nearby Main Street. Together, these large retail spaces shaped the style of Mount Prospect's downtown area.

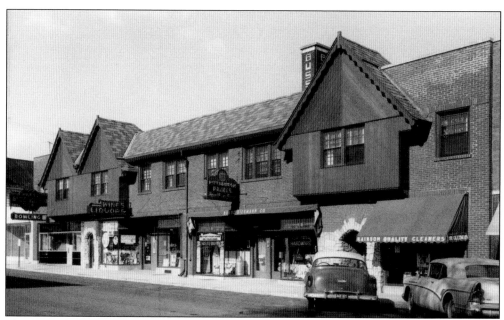

The exposed timber sections of the Busse commercial building's facade were covered up within the first 30 years after it opened. George L. Busse snapped a photograph of this new look in November 1959. One well-known tenant (pictured in the center) is Busse-Biermann Hardware Store, which had moved from the building next door. The sign for Mount Prospect Bowling Lanes is on the far left; it was one of the first bowling alleys in town.

Busse-Biermann Hardware Store originally began as part of the International Harvester farm equipment dealership and William Busse's Buick dealership, which opened in 1912. In the late 1920s, Busse divided the three businesses and gave the hardware store to his son-in-law and employee, Frank Biermann. The undated photograph above shows a hardware store window advertising lawn-care supplies in its second location on West Busse Avenue. Biermann (pictured at right inside the hardware store) ran the business until 1973 and became well known for his friendliness and leadership. Outside of working hours, Biermann was Mount Prospect's first volunteer fire chief and remained in that position for almost 30 years.

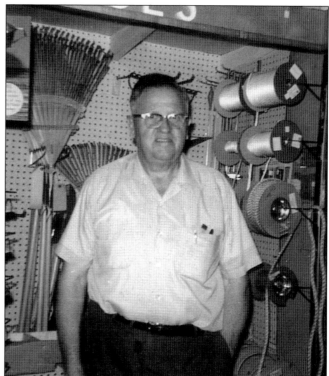

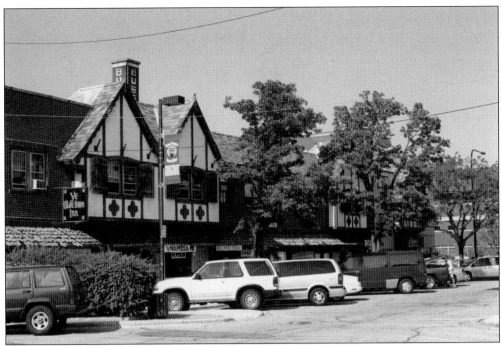

By the early 21st century, the Village of Mount Prospect was considering this section of West Busse Avenue for redevelopment. The building on the corner, partially obscured by trees, was demolished not long after this photograph was taken in June 2006. The Tudor-style structures of West Busse Avenue were the last historic buildings standing in this part of downtown Mount Prospect as of 2023.

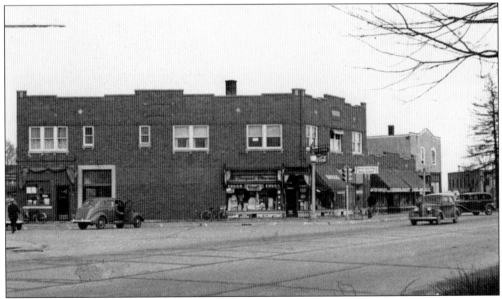

This building on the corner of Northwest Highway and Emerson Street was constructed by Edward Busse in 1925. Shortly after it was completed, it was praised in a Chicago real estate journal as "the first genuinely modern business building" in Mount Prospect. The large brick structure offered ample room for businesses on the main level and office space above one section, as showcased in this 1930s photograph of the corner.

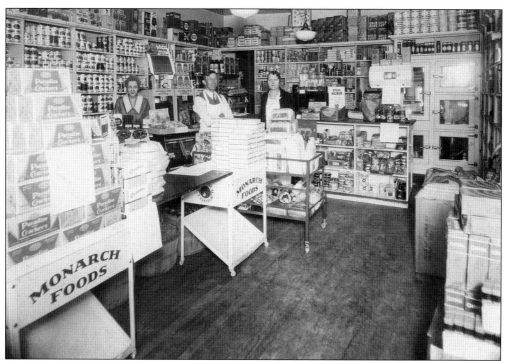

Edward Busse's son, Edwin, opened a grocery store in this building in 1925, the same year its construction was finished. It was one of the first fully stocked grocery stores in town, making it a much-needed modern convenience for a rapidly modernizing town. This image offers a glimpse inside Edwin's grocery store during the 1930s. Edwin is standing in the center, and the woman on the right is Loretta Rateike.

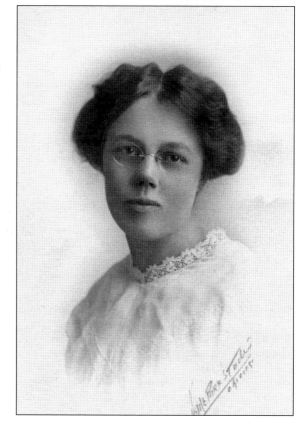

One early office tenant in this building was Dr. Louise Koester, who is pictured as a young woman. She established her practice in 1926, becoming the town's first doctor. Although some were skeptical about the abilities of a female doctor, Dr. Koester had a very successful career. Only six years after her practice opened in the Edward Busse building, she moved her office to a larger space in her home on Owen Street.

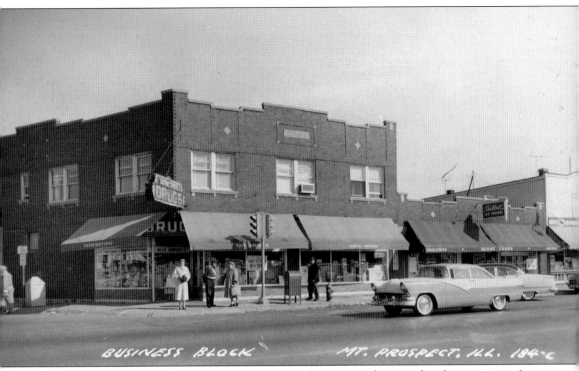

BUSINESS BLOCK MT. PROSPECT, ILL. 184-C

Van Driel's Drug Store is a longtime Mount Prospect business, and it started in the corner storefront of the Edward Busse building. In 1942, Herb Van Driel purchased the pharmacy already located in that space. Most of his early business came from lunch counter sales rather than prescriptions, because local doctors had a preexisting agreement with another pharmacy. This photograph shows the pharmacy in the 1950s with a neon sign above the entrance. At that time, Edwin Busse's grocery store was still operating next door as Busse Foods. The pharmacy business grew after World War II, so Herb hired Max Ullrich, who then purchased the pharmacy when Herb retired in 1968. Competition from chain-store pharmacies encouraged Ullrich to convert the pharmacy to a medical supply store in the early 1970s. Van Driel Medical Specialties stocked items like walkers and canes and added compression wear in the 1980s thanks to input from Max's wife, Irmi. The business moved to a space farther down Northwest Highway in 2006, and it is still run by the Ullrich family.

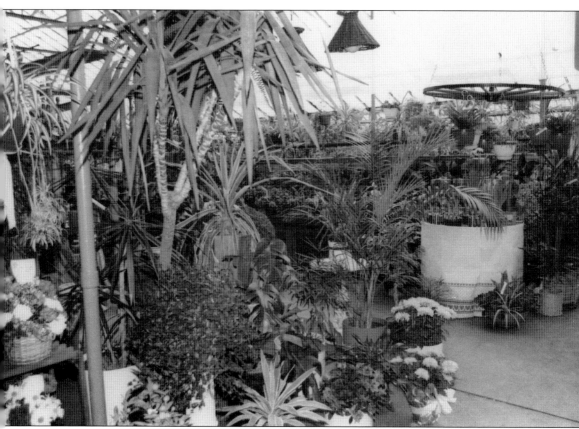

Busse's Flowers and Gifts began in a shop and greenhouses at 303 East Evergreen Avenue, near Northwest Highway. This new location was the shop's third place since Louis Busse and his son, Fred, began selling flowers wholesale in 1916. When Van Driel's Drug Store moved out of this corner storefront in 2006, Busse's Flowers and Gifts moved in in 2007. The new location was in downtown Mount Prospect and offered the chance to refocus on the flowers side of the business rather than giftware and collectibles. One highlight for customers was visiting the resident birds, Annie and Perry—appropriately, the birds' full names were Annual and Perennial. This photograph shows the interior of one of the greenhouses before the business moved to a new building along Northwest Highway in 1987. Busse's Flowers and Gifts is still owned and operated by descendants of Louis and Fred Busse but moved to a neighboring suburb in 2019.

The Edward Busse building received a new look in 1985 as part of Mount Prospect's Façade Improvement Project. This local project aimed to update the exteriors of downtown business buildings and create a cohesive, modern appearance for the downtown area during the mid-1980s. Upgrades to this building included green awnings above storefront entrances and windows and painting that emphasized the original architectural features. The changes from this project are evident in the summer 1985 photograph from before the project (above) and the November 1985 photograph taken after work was completed (below). In late 2022, the building was sold to a local developer, and its future remains unclear.

Two

HIDDEN IN PLAIN SIGHT

Many buildings and sites in Mount Prospect have a longer history than most residents realize, and as a result, they are often not considered historic at all. Some of these buildings were products of the post–World War II population boom. Their modern designs have stood the test of time and still seem "too new" to be historic. Some shopping centers fall into this category, especially because they are not traditionally considered historic sites. Other sites have simply blended in with their surroundings. Roadways and parks, for instance, do not show their age in the same way buildings do. This chapter highlights some of the historic places in Mount Prospect that are hiding in plain sight.

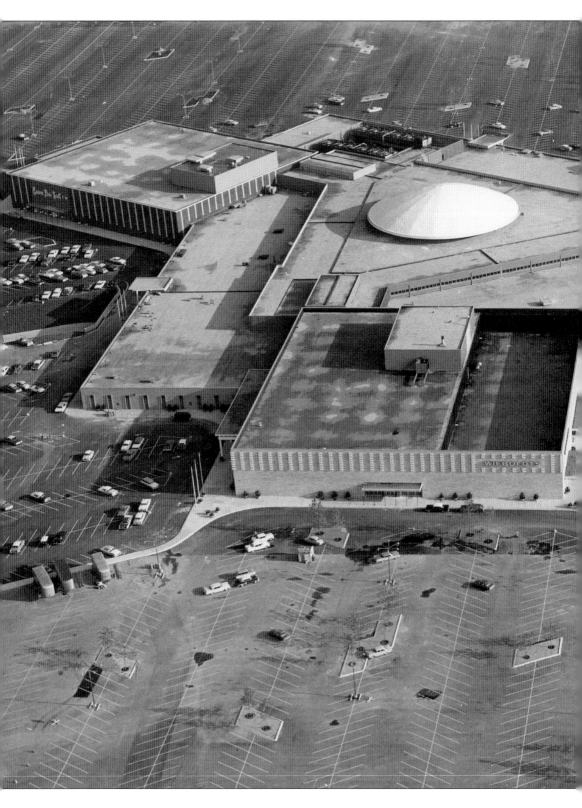

Randhurst Shopping Center opened on August 16, 1962. At the time, it was the Chicago area's first regional shopping center and the largest air-conditioned space in the United States. Victor Gruen, a leading commercial architect in the mid-20th century, designed Randhurst in a distinctive triangle shape. It gave Mount Prospect an economic advantage, and over the following decades, it also became a community gathering place for residents in the northwest suburbs. Longtime residents have many memories of shopping, working, and attending events at the center. As a result, this site holds a special place in the community's heart. This aerial photograph was taken the year Randhurst opened. The department stores shown here are, from left to right, Carson Pirie Scott, Wieboldt's, and the Fair. The Fair became Montgomery Ward about a year after the shopping center opened.

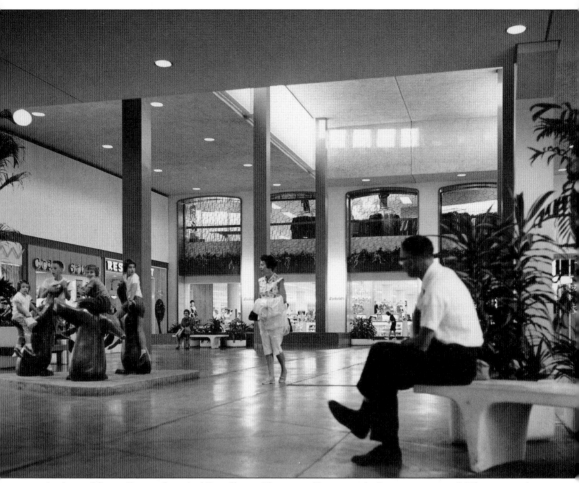

Architect Victor Gruen designed Randhurst Shopping Center with shoppers in mind. The triangular layout shortened walking distances, but there were ample benches on which to rest and fountains and sculptures to enjoy. This 1960s image shows shoppers enjoying all of the above outside Wieboldt's mall entrance. The biggest fans of the art, however, were the youngest shoppers. Four children are climbing on the penguins on the left, just as many children did in the following decades. Randhurst also offered a community meeting space at the town hall on the lower level. The auditorium had a projection booth, a curtained stage, and space to seat 400 guests. Many local organizations held meetings at the town hall, including the Mount Prospect Junior Chamber of Commerce and the Mount Prospect Rotary. The basement was another amenity; it mainly provided an out-of-sight service entrance for deliveries, but it could also serve as a fallout shelter for the entire town in case of a nuclear attack.

Adults and children living near Randhurst Shopping Center looked forward to special events all year. The design team always set up elaborate displays for Easter and Christmas. The photograph at right of Santa Claus arriving at his snow castle in 1989 demonstrates the team's dedication to transforming the mall. Various showcases also became staples of Randhurst's event lineup. Car shows (like the one below from 1965), police and fire department shows, and art shows were regular occurrences into the 1990s. These events helped knit Randhurst into the fabric of the surrounding community by offering opportunities for residents to gather and enjoy themselves.

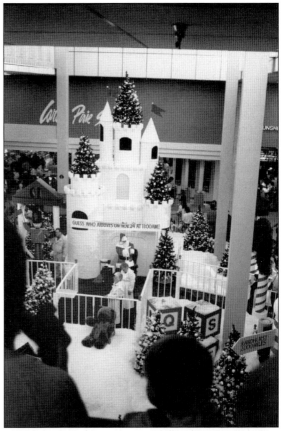

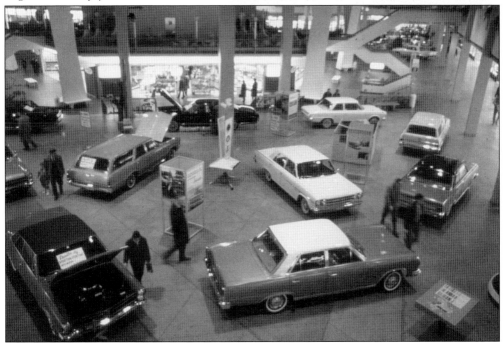

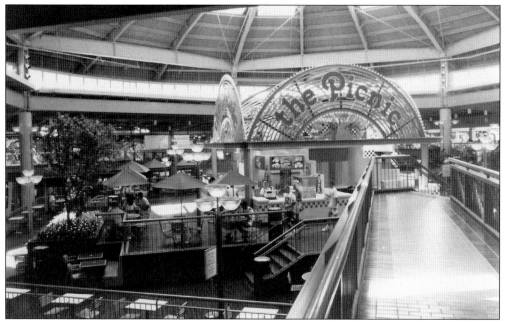

By the 1980s, Randhurst Shopping Center needed an upgrade, so it underwent an extensive remodeling project. This included the creation of a food court, called the Picnic, in the top level of space directly under the dome. It opened on October 4, 1984, with a ribbon-cutting ceremony and a celebrity guest—Oprah Winfrey—drawing the name of the winner of a $1,000 shopping spree. The iconic red sign is a prominent feature in this 1980s photograph.

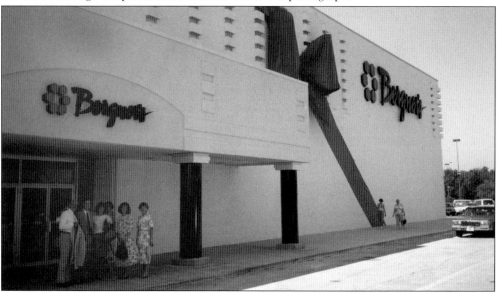

Despite decades of adapting to new economic challenges, Randhurst Shopping Center closed on September 30, 2008. Over the next three years, the indoor mall was transformed into the outdoor lifestyle mall called Randhurst Village. The only remaining part of the original structure is the former Wieboldt's building, which at the time of publication houses HomeGoods. The building's distinctive brickwork, which also remains, is pictured from when Bergner's opened in the building in 1988.

Countryside Bank's new home on Elmhurst Road was dedicated with a tree-planting ceremony on March 3, 1971. The bank's president, John J. Riordan, noted that the tree represented the bank's investment in the community. The building offered customers an improved banking experience with more teller windows, drive-up windows, and a walk-up window. The bank is the building with the arches pictured near the center of this 1970s photograph.

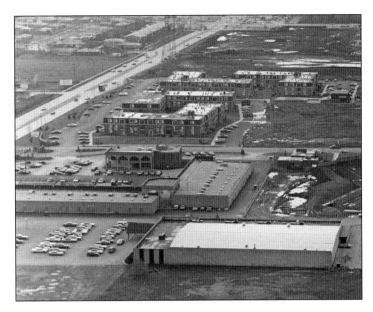

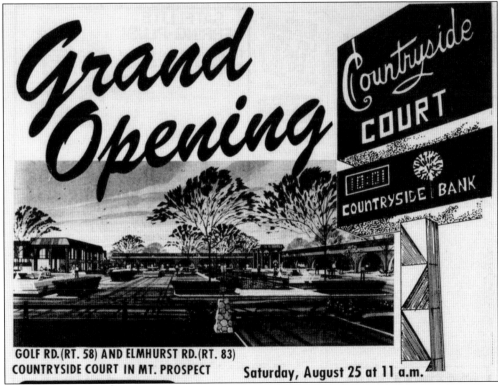

In 1973, two years after Countryside Bank opened, the adjacent Countryside Court Shopping Center held its grand opening. This advertisement in the *Wheeling Herald* announced the celebration. Some of the festivities included a ribbon-cutting ceremony with Mayor Robert Teichert and Miss Mount Prospect Susan Busch, a puppet show, and a Packard Auto Show. The center's early advertisements highlighted its landscaping, which included a pond with a bridge in the parking lot.

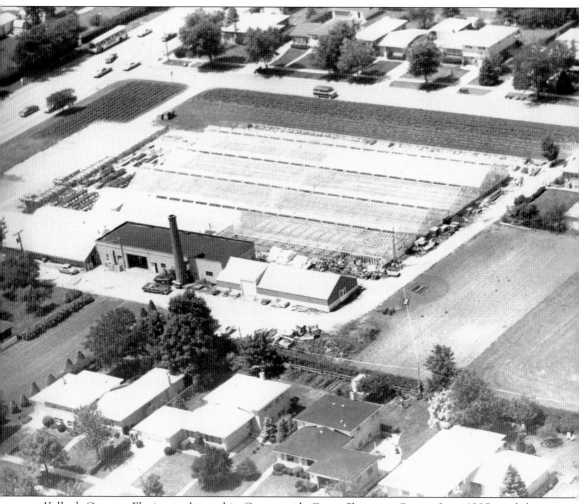

Kellen's Country Florist was located in Countryside Court Shopping Center from 1985 until the late 2010s. This family business began around 1900 as Kellen's Greenhouse in the Rogers Park neighborhood of Chicago, and it later added a second location in Des Plaines. In 1950, brothers John, Joe, and Jake Kellen opened a third greenhouse in Mount Prospect at 618 East Golf Road. They focused on selling wholesale plants, but their small roadside shed of retail plants had such impressive sales that the brothers officially added a retail business in the early 1960s. With that addition, the company's name was changed to Kellen's Country Florist. The greenhouse on Golf Road is pictured here in the early 1980s. By 1985, land taxes had risen, and John sold the greenhouse land to the Chicago Assembly of God Church; the retail business moved to Countryside Court Shopping Center. (Courtesy of Vince Kellen.)

Construction began on Mount Prospect Plaza Shopping Center in October 1958. At the time of the ground-breaking ceremony, about 90 percent of the store area was already under lease. The plans included almost 40 storefronts, making it a one-stop shopping experience for area residents. Shoppers could anticipate beautiful landscaping, canopied walkways between stores, and a lighted parking lot that could accommodate over 2,000 cars. Construction is well underway in this photograph.

Mount Prospect Plaza underwent a few renovations over the years, but it retained its iconic Y shape. Some of the early tenants are visible in this 1960s aerial view, including Hillman's Fine Foods, Walgreens, Woolworth's, and Goldblatt's. The area around the shopping center changed in more dramatic ways as new homes and businesses filled in the surrounding fields.

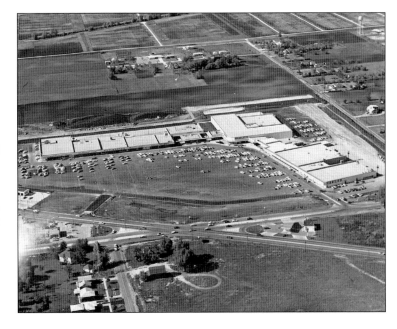

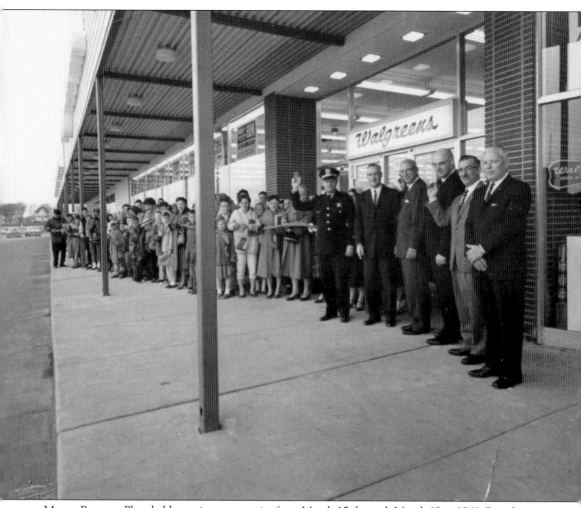

Mount Prospect Plaza held opening ceremonies from March 15 through March 18 in 1961. Significant construction delays dampened the four-day celebration and resulted in an unfinished parking lot and some stores not being able to open on time. Despite the less-than-ideal situation, the Mount Prospect Plaza Merchants' Association celebrated in style with giveaways and drawings. Some of the association's prizes included a weekend for two in Las Vegas, a complete family Easter wardrobe, and Philco portable television sets. There was even a fireworks display. Other stores advertised their own giveaways. For example, Kroger shoppers could win a Westinghouse upright freezer or a silver service set. Walgreens was one of the stores with a delayed opening, but this photograph shows how crowds still gathered when it finally opened in April 1961. The police officer waving at the camera is George Whittenberg, the second officer hired in Mount Prospect.

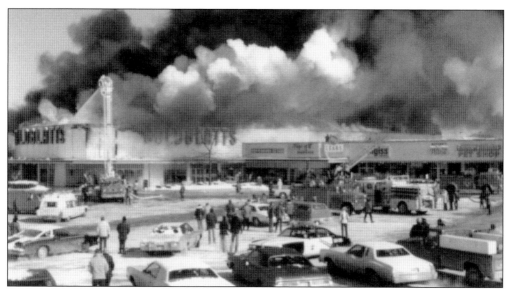

Fire destroyed the Goldblatt's store on February 6, 1977. The Mount Prospect Fire Department needed help from nine other suburban departments to extinguish the massive fire—its size is evident in this photograph of the billowing smoke. A park featuring the *Hula Pole*, a giant kinetic sculpture by George Rhoads, replaced the Goldblatt's building until a new structure was built by the late 1980s. (Courtesy of George Stiener.)

Members of the Veterans of Foreign Wars Post No. 1337 came together to build this clubhouse on Route 83 between 1949 and 1950. At the time, Mount Prospect's VFW desperately needed a larger facility to accommodate the growing number of World War II veterans joining the organization. Veterans in uniform posed for this group photograph in front of their clubhouse before lining up for the 1965 Memorial Day parade.

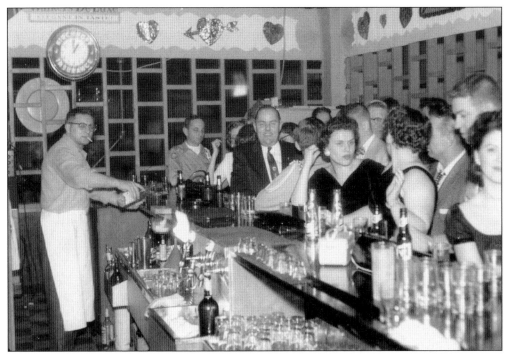

VFW Post No. 1337 held social events at the hall, such as holiday gatherings and dinners. Civilians could join as social members or rent the facility for events. This clubhouse became an important place for the community to gather, especially in a time before there were many local places to do so. Here, partygoers gather around the bar at the Deutsches Fest on February 22, 1958, sponsored by the 1337 Drill Team.

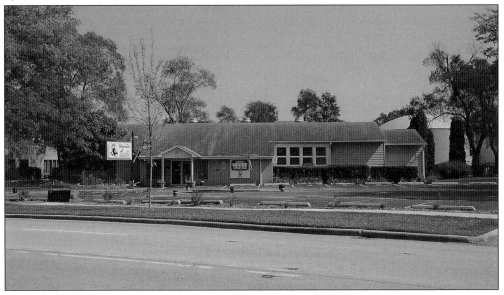

VFW membership had declined by the 1970s, and the organization hired outside management to run the clubhouse. The VFW eventually sold the building to Moose Lodge No. 660 in 1983. In early 2021, the VFW and the American Legion returned to this building for their meetings, and it is now home to three community organizations. This photograph of the building was taken in 2020.

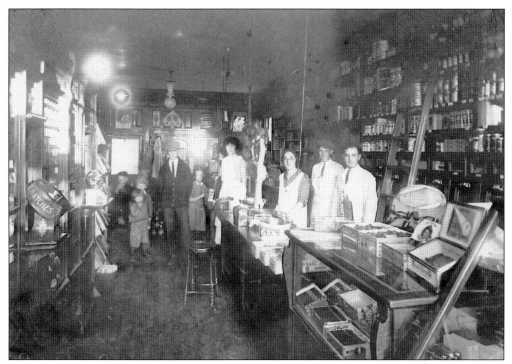

Fred Meeske purchased William Busse Jr.'s grocery store in 1925 and renamed it Meeske Food Market, which opened in the Tudor-style building along Main Street. The above photograph shows the interior of the tiny grocery store around that time. Fred is standing behind the counter at far right. Business grew, and in June 1950, Meeske's moved next door to a new, modern store on the corner of Main Street and Busse Avenue; the newspaper advertisement below shows that building's exterior. Fred's sons, Earl and Fred Jr., retired in 1973 and sold the grocery store to Robert Burton. Meeske's permanently closed in 1984 due to competition from larger chain grocery stores. For over 50 years, locals loved Meeske's for the store's friendly customer service and exceptional butcher shop.

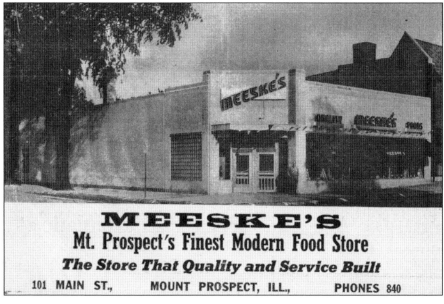

MEESKE'S
Mt. Prospect's Finest Modern Food Store
The Store That Quality and Service Built
101 MAIN ST., MOUNT PROSPECT, ILL., PHONES 840

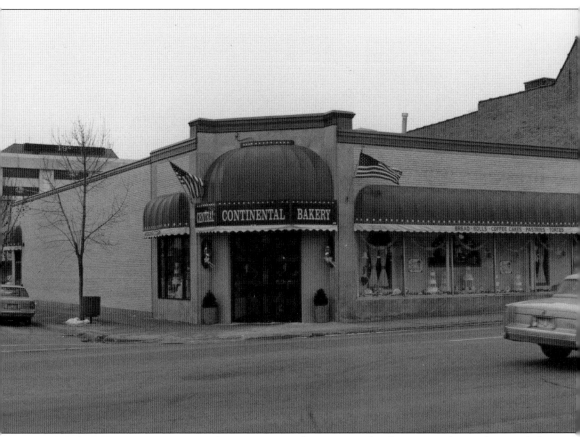

Another iconic Mount Prospect business, Central Continental Bakery, moved into the Meeske's storefront shortly after that business closed in 1984. Central Continental Bakery set up its first Mount Prospect location in Central Plaza shopping center in 1979—the "Central" part of the business's name is a reference to that location. Before moving into the old Meeske's building, the bakery's owners extensively remodeled the interior. This photograph was taken in 1986 after the remodel was completed. Although exterior details had changed, the building remained recognizable. One of Central Continental Bakery's most well-known traditions is the Paczki Fest, which is held to celebrate Paczki Day, or Fat Tuesday. The bakery's delicious Polish filled doughnuts draw customers from all over the northwest suburbs. In 2014, the Paczki Fest was almost cancelled; shortly before the weeklong celebration, a fire in the building next door damaged the Central Continental Bakery building and forced the bakery to relocate. Fortunately, Paczki Fest was able to be set up in nearby Prospect Place Shopping Center, and the bakery returned to its Main Street location before the end of the year.

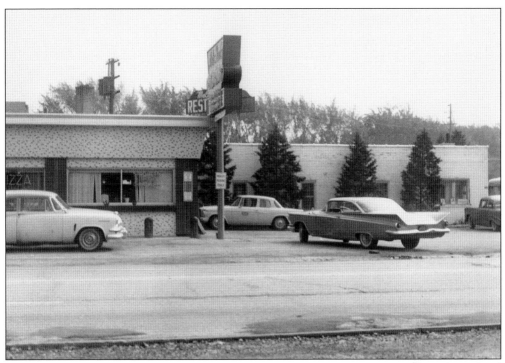

Myrt and Bill Hampe began operating a seasonal lunch wagon on the corner of Central Road and Northwest Highway in 1948. Their hot dogs and burgers were so popular that a year later they built a restaurant to keep up with the increase in customers. The Hampes sold that restaurant to Carmella and Paul Caltagirone in 1952. The Caltagirones' business, Mell and Paul's Restaurant, was a local favorite for Italian American food. The menu included ravioli, spaghetti, steaks, seafood, and "pizza at its best." These photographs capture the Mell and Paul's sign and customers parking outside the restaurant some time in the 1950s.

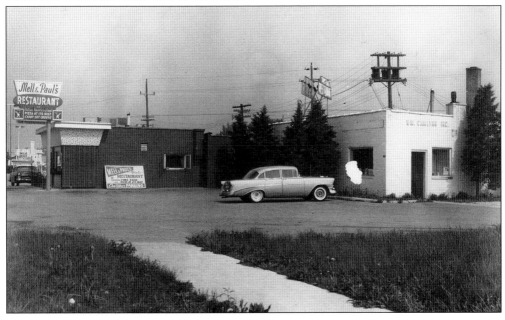

Mell and Paul Caltagirone sold the restaurant to Bill Golden in 1962. His Golden Isle Restaurant specialized in pizza but was short lived. In 1965, Jake's Pizza moved into the building. This postcard highlights some of the exterior renovations. Jake's became a beloved local pizza place over its almost 50 years in Mount Prospect. Locals were devastated when it closed in 2013. The building is now home to Trezeros Kitchen + Tap.

William Kirchhoff and his son, Louis, once owned farmland north and south of West Central Road. Kirchhoff descendants farmed this land until George and Elsie retired to Wisconsin in the 1950s. The farmhouse became the American Legion's headquarters, and the land was zoned for light industry. This photograph shows members of the Kirchhoff family dining in their barnyard. The family home and two outbuildings are visible in the background.

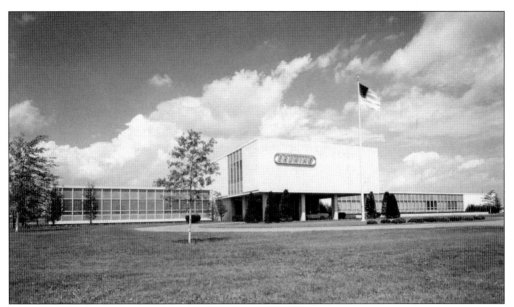

The Charles Bruning Company was one of the first manufacturers to move to the land that once held the Kirchhoff family farm. The company made blueprints and produced drafting and printing machinery. Its Mount Prospect location was a large, modern facility that boasted a courtyard, shown here in a company photograph. The above photograph from the 1950s or 1960s shows the facility's exterior. Bruning later merged with Addressograph Multigraph Corporation, and the company's name was eventually changed to AM International. Since this stretch of Central Road was zoned for industrial use, Bruning gained a few neighbors over the years, like Commonwealth Edison and Illinois Bell Telephone Company. Other businesses west of Bruning's headquarters included the Illinois Range Company, Milburn Brothers Incorporated, and Edward Hines Lumber.

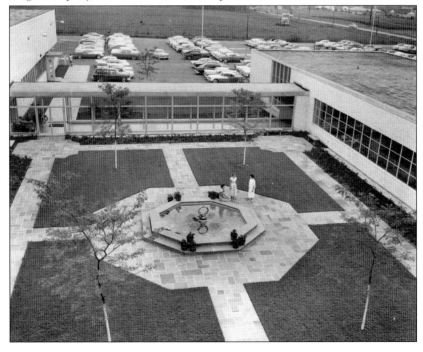

Much of the rest of the former Kirchhoff farm was an important drainage site from nearby Weller Creek, so the landowner, the Metropolitan Water Reclamation District of Greater Chicago (MWRD), began building a retention basin in 1977. This development reduced creek flooding, and, as an added bonus, served as a sledding hill during the winter. While the MWRD owned the land, both the Mount Prospect and Arlington Heights Park Districts subleased the property from the Village of Mount Prospect. Together, the districts planned to develop the area into a park. In 1982, the land was dedicated as Melas Park in honor of MWRD president Nicholas J. Melas. This photograph shows Mount Prospect mayor Carolyn Krause (at center stage) surrounded by other local officials. Melas responded to the honor by teasing that he was "glad they didn't wait until I was dead."

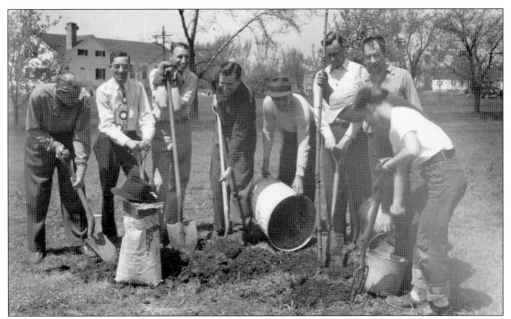

The Mount Prospect Lions Club purchased a section of farmland south of downtown in 1947. The club created a park and dedicated it to all those who died while serving in World War II by naming it Lions Memorial Park. Local Lions Club members are working together to plant a tree in the new park in this undated photograph, which was likely taken shortly after the park's purchase or dedication.

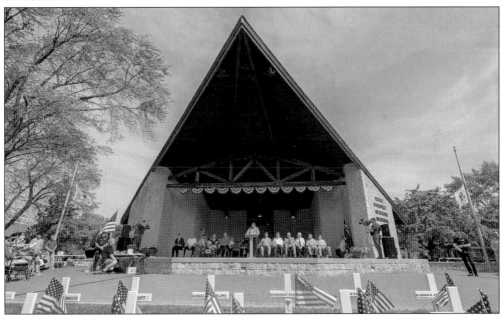

Lions Memorial Park continues to be a special place for veterans. In the mid-1990s, members of the Veterans of Foreign Wars and American Legion created a band shell as a living memorial to veterans. They dedicated it on Memorial Day in 1999. Since then, it has hosted many Memorial Day ceremonies, like this one in 2022, as well as community concerts and other performances. (Courtesy of Mike Zarnek Photography.)

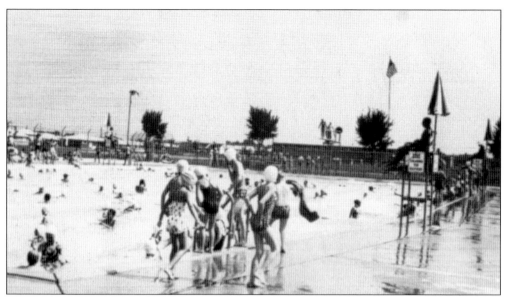

In the mid-1950s, Lions Memorial Park became home to Mount Prospect's first public swimming pool. A 1954 heat wave inspired the idea to create a town swimming pool, which also prompted the establishment of the Mount Prospect Park District a year later. Shortly after the park was dedicated in 1947, funds were approved to add a pool to the park. This photograph shows children cooling off in the Lions Pool. Approximately 30 years later, the Lions Pool was converted to Big Surf Wave Pool, one of the first wave pools in the Chicago area. Below, swimmers ride the waves on inflatable rafts in the late 1980s or early 1990s. Whether a standard pool or a wave pool, the pool at Lions Memorial Park has been the source of fond summer memories for generations of residents. (Below, courtesy of Mount Prospect Park District.)

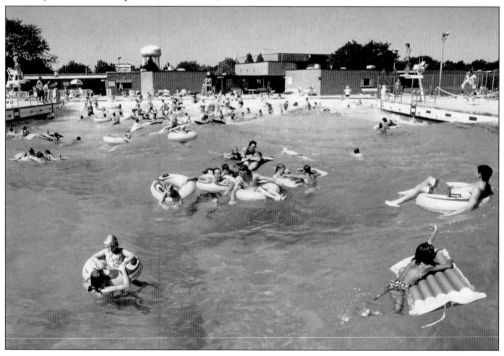

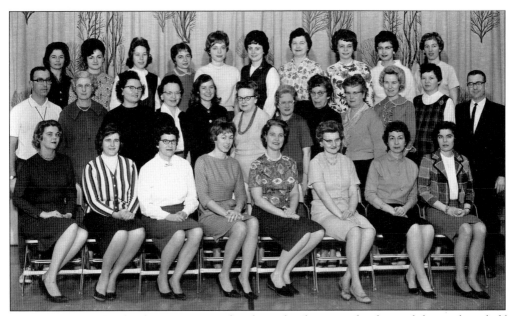

In 1956, Lions Park School was constructed at the park. This new school served the southern half of Mount Prospect as the number of school-age children grew rapidly during the population boom of the 1950s and 1960s. Some of the school's staff members are pictured here in 1964. By the 1990s, the school needed a complete overhaul, and a new building opened in time for the 1996 school year.

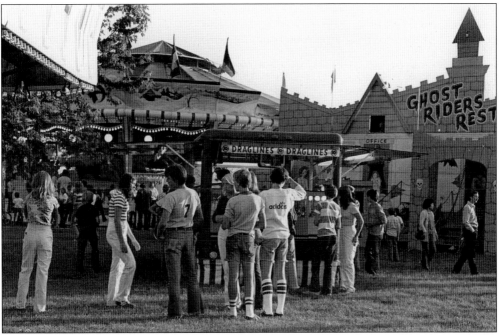

The Lions Club has hosted an annual summer festival since the 1930s, and by the 1960s, this celebration was being held around the Fourth of July at Lions Park. Longtime residents fondly recall attending decades of parades, fireworks, and carnivals. Visitors are waiting outside a booth in this photograph from the 1978 carnival. In 1980, the festivities moved to Melas Park through an agreement with the Metropolitan Water Reclamation District.

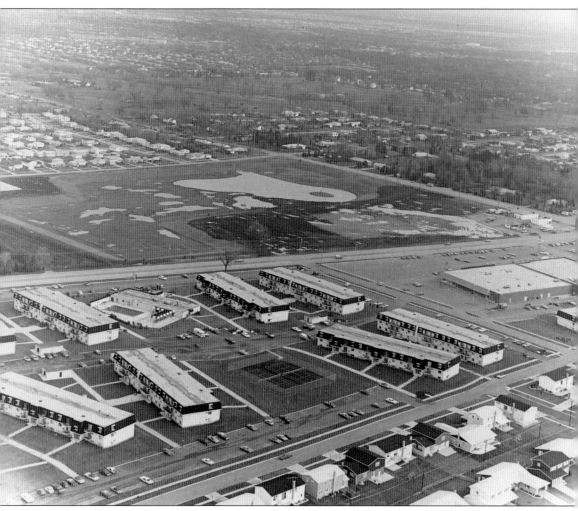

Robert T. Jackson Clearwater Park, originally called West Park, stands on the former Busse and Meier farms surrounded by Lonnquist Boulevard and Busse and Golf Roads. The Village of Mount Prospect and Mount Prospect Park District purchased the land from developer Salvatore DiMucci in 1969, and it was renamed in the 1970s. Robert T. Jackson was president of the board of park commissioners when the park was added to the Mount Prospect Park District. Improvements to the park began the following year and included a recreational pond, visible in the center of this 1970s aerial view, and a playground. The playground was dedicated to Betty J. Hedges in 1976. She was a unit secretary and unit manager at Forest Hospital in Des Plaines who had passed away from cancer the previous year. Since she and her family lived near Clearwater Park, Forest Hospital donated $10,000 to the Mount Prospect Park District in her memory. The generous donation went toward developing the park and adding a boulder with her name and the word "joy" in reference to the hearts of children.

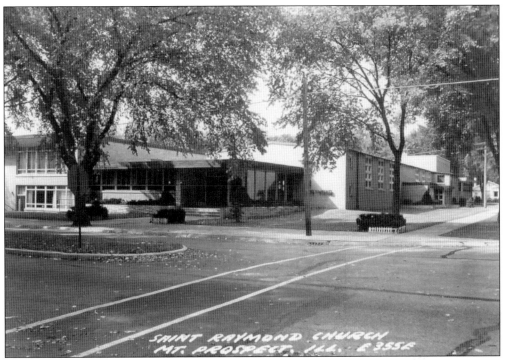

The population boom of the 1920s brought some of the first Catholic families to the largely German Lutheran Mount Prospect. Twelve of these newcomers formed the Mount Prospect Catholic Woman's Club in 1931. They wanted to establish the first Catholic church in town and wrote letters to the Archdiocese of Chicago until St. Raymond Catholic Church was formed in 1949. The first Masses were celebrated in the basement of the second Central School before the church was completed in 1952. That church was later incorporated into the school as the gymnasium and auditorium. The school, shown above in the 1960s, opened for classes in 1954. The current church, pictured below in 1974, was dedicated in 1962.

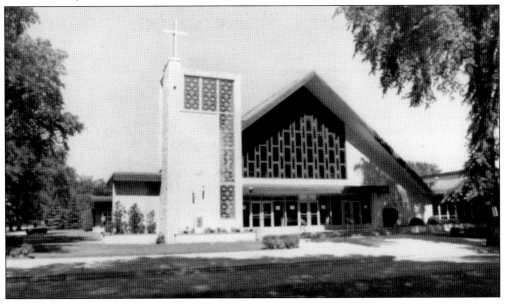

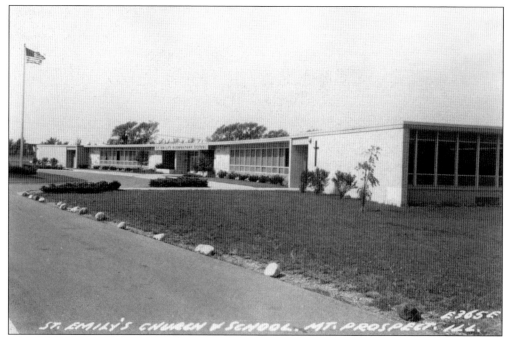

St. Emily Catholic Church was established in May 1960 to serve Catholic families living near Wolf and Central Roads, which was then an unincorporated section of Cook County. Fr. John McLoraine celebrated the first Mass for the parish in the Maryville Academy gymnasium, and the community continued to meet in temporary spaces for the next decade. St. Emily Catholic School opened in 1961, providing one space for Masses, but eventually the community also needed to use the school's basement and space in nearby Euclid School. The 1960s photograph above shows the school building. The permanent church was finally dedicated on May 9, 1971. That church, shown below in 1974, is unique because it is circular. The altar is in the center with those in attendance seated around it.

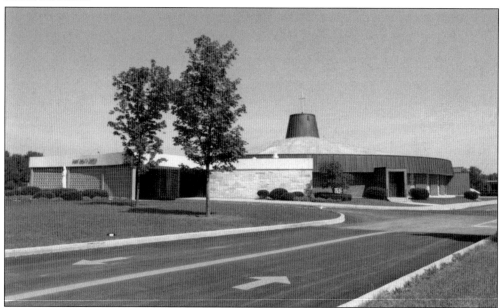

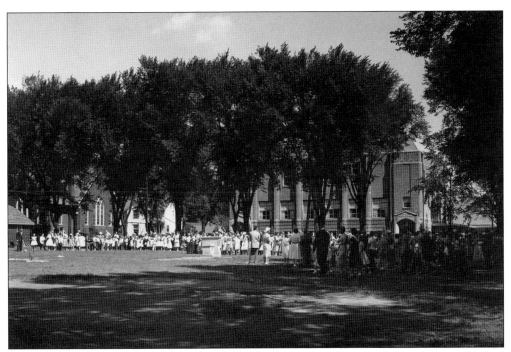

The St. Paul Lutheran Church congregation is older than Mount Prospect, having been established in 1912, five years before the village was incorporated. The original church building was constructed on the corner of Elm Street and Busse Avenue in 1913. During the population boom of the 1950s and 1960s, however, the congregation needed to expand its facilities. The community broke ground for the new church in 1959. The above photograph shows the crowd on the site of the new church, with the school (right) and the old church (left) in the background. The St. Paul community gathered once again to dedicate the new church in April 1961. That new church, pictured below shortly after its completion, continues to serve the community. The 1913 church building was later demolished, and a garden dedicated to the first pastor, J.E.A. Mueller, now stands in its place.

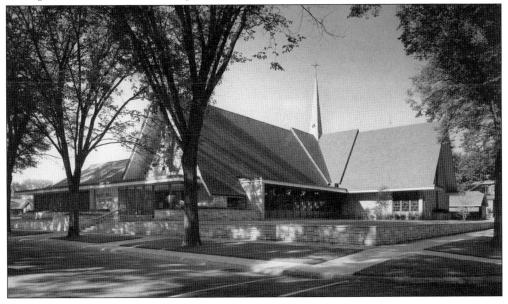

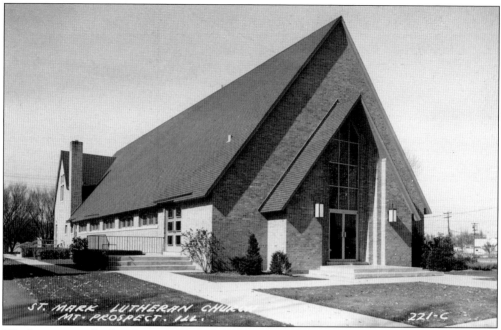

Worship services for the Mount Prospect Evangelical Lutheran Church congregation (later named St. Mark Lutheran Church) began in the basement of the second Central School in 1945. The first church building was a small concrete structure completed in 1948, but several additions over the next few decades significantly expanded the church facilities to include an education wing and a multipurpose center. This postcard from around 1960 shows the church's exterior.

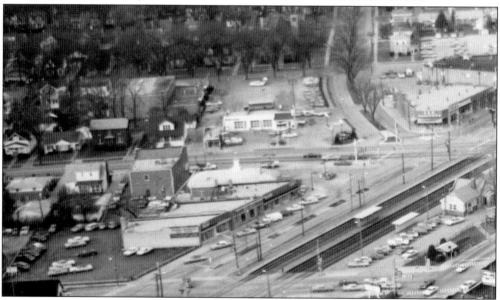

The real estate agency T.J. Tindall and Sons occupied the tiny building at 208 South Main Street in the mid-1950s. It is in the center of this 1967 aerial view near the short, wide building. T.J. Tindall and Sons was one of many realtors during the postwar population boom before it was acquired by Arlington Realty in 1967. Hubby's in the Dog House, a hot dog stand, opened in this structure in 2019.

Henry W. Friedrichs Sr. opened a suburban branch of the family's southside Chicago Friedrichs Funeral Home in Mount Prospect in 1958. Henry Jr., known as Hank, is pictured above with his daughter Jill at the annual Lions Club Fourth of July Festival during the 1980s or 1990s. The new ranch-style building on Central Road, pictured on the right side of the below photograph shortly after completion, matched the homes in the surrounding subdivision. The Mount Prospect branch of Friedrichs Funeral Home formally opened in October 1958; however, the first wake was held in September for Clarence Winkelmann, the owner of the Shell gas station across the street. The funeral home is still owned and operated by Henry's descendants. (Above, courtesy of Jill Friedrichs and family.)

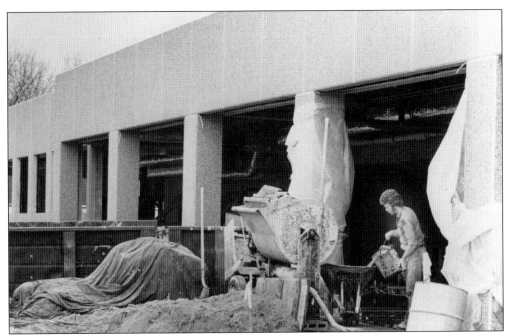

Mount Prospect's current post office on Central Road is the town's third freestanding post office. It was double the size of the previous building and had significantly more parking for staff and customers. The structure's distinctive rough-textured exterior is nearly complete in this construction photograph from November 1975. Despite disputes over local building codes, the new post office opened in 1976.

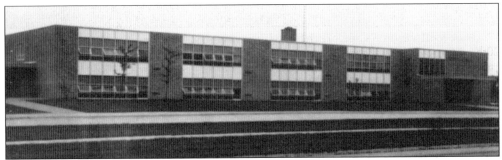

Gregory School opened in 1963 despite legal disputes with the previous landowner. It was the last school built to accommodate children from the mid-century population boom but was also open for the shortest amount of time, closing in 1975. In 1982, Christian Life Church and College purchased the vacant school and transformed the building and grounds into a campus. (Courtesy of Mount Prospect School District 57.)

Like many local schools, Prospect High School was established to relieve overcrowding after the mid-20th century population boom. Arlington High School had educated students from both Arlington Heights and Mount Prospect since 1922, but the communities desperately needed more space by the 1950s. High School District 214 chose a site in Mount Prospect along Kensington Road for the new Prospect High School. The first students walked through Prospect's doors in 1957, as shown in this photograph from the first day of school. Initially, only freshmen and sophomore students attended classes at the school, but juniors and seniors were gradually added. The contemporary-style building featured a theater, library, gymnasium, and field house. The main structure remains in use today, but Prospect has undergone remodeling and expansions. Some of the additional features include a fine arts wing and a swimming pool.

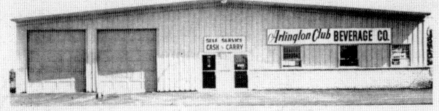

Quench your thirst
... by the case!

SELF SERVE
CASH-CARRY

Arlington Club BEVERAGE CO.

SINCE 1872

Arlington Club Beverage Co.

1326 W. Central Road • Mt. Prospect
CL 3-0030

The Arlington Club Beverage Company began in Arlington Heights in 1872 but moved to the Pop Shop in Mount Prospect in 1964. Locals fondly remember the beverage company's many delicious flavors of bottled pop. This newspaper advertisement shows the exterior of the company's headquarters on Central Road. The company closed in 1991, and the Mount Prospect Park District purchased the building and opened the Art Studio there in 1997.

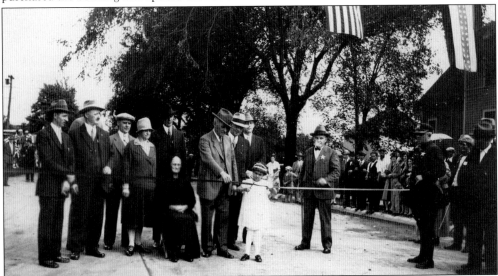

Mount Prospect celebrated a modern milestone with a ceremony to reopen the freshly paved Main Street in October 1927. Like the new commercial buildings along the street, this advancement showed that the small community was thriving only 10 years after it was incorporated. A photographer snapped this pictured of Verna Maleske cutting the ribbon with some help from Mayor William Busse. Others present included developer Axel Lonnquist and William's mother, Christine.

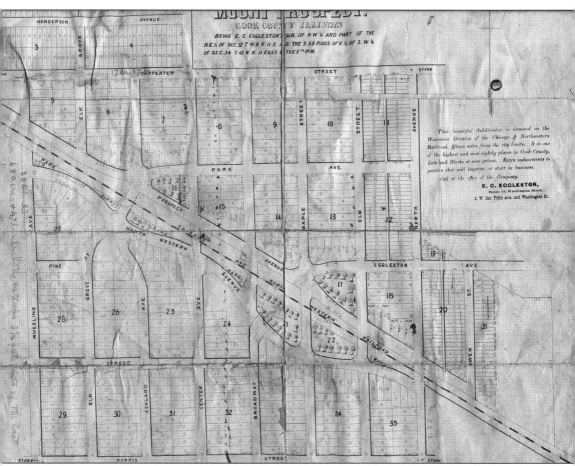

When Ezra Eggleston mapped out Mount Prospect in 1873, he gave the name Prospect Avenue to the street running north along the Chicago & North Western Railway tracks. Eggleston's map shows how this dirt road, along with the train tracks, cut the entire subdivision in half. This inconvenient layout was worthwhile because it allowed for a train station. Access to the train connected local farmers to profitable markets in Chicago and added an incentive for people to move to Mount Prospect. While Mount Prospect's early development mostly followed Eggleston's plan, many streets were renamed as the community became more established. Center Avenue, for instance, became Main Street (or Illinois Route 83). Park Avenue was renamed Busse Avenue to honor the Busse family. The curvy street south of the train tracks (labeled North Western Avenue) later adopted the name Prospect Avenue when the original Prospect Avenue became Northwest Highway.

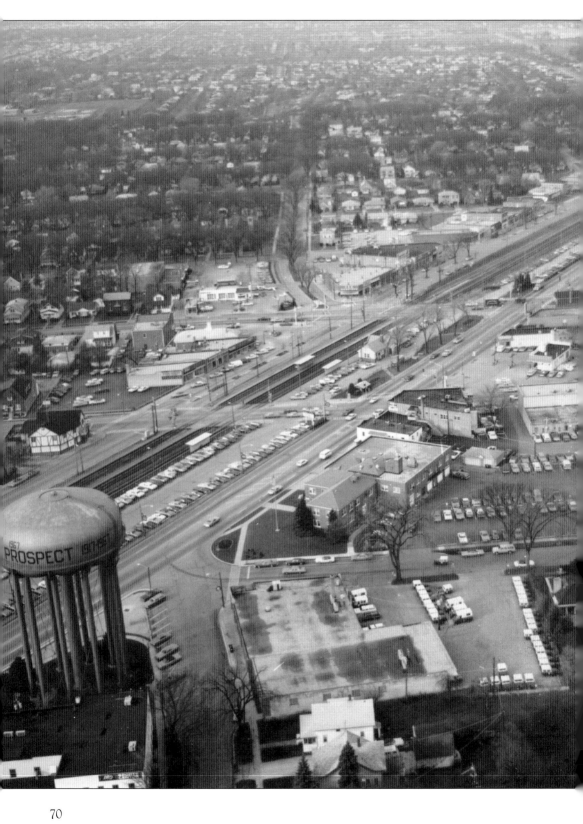

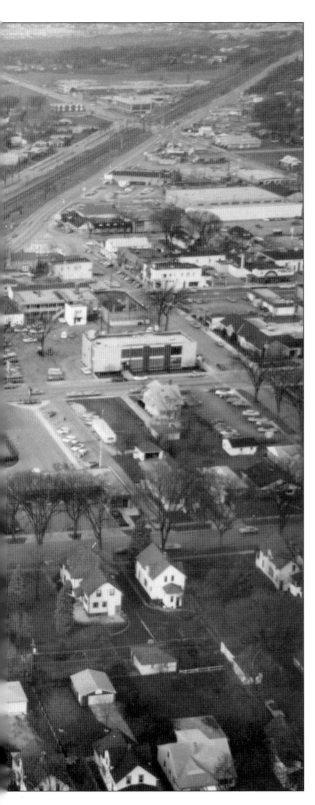

After World War I, Mount Prospect mayor and Cook County commissioner William Busse teamed up with neighboring Arlington Heights mayor Al Volz to improve area roadways. Officials from other towns along the Chicago & North Western Railway also joined the project. Together, they tackled Prospect Avenue, which became Northwest Highway when it was paved. The paved highway, later designated US Route 14, put the newly incorporated Mount Prospect on the map and connected residents to other communities along the route between Chicago and Wisconsin. This aerial view dates to around 1967 and showcases downtown Mount Prospect during a period of rapid growth. Northwest Highway is the central road crossing the photograph on a diagonal. Many businesses, and even the town's municipal building, had popped up along the route since it was paved approximately 40 years earlier.

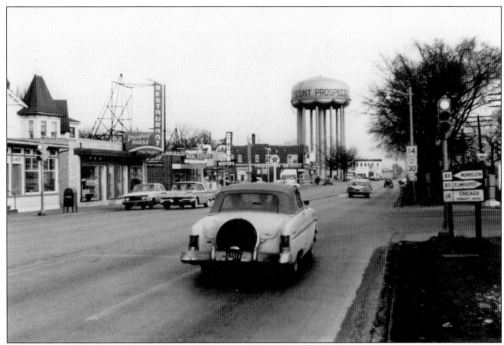

The above postcard of Northwest Highway, with a photograph taken in 1961 where the road crosses Route 83, offers a short history of Mount Prospect in one glance. The buildings along the road show the town's early history as represented by the Moehling family's general store and their house's turret on the left, through the commercial developments stemming from population booms after World Wars I and II. The below photograph, taken in approximately the same spot, dates to 1987. Despite over 20 years of change, the two images are remarkably similar. This section of Northwest Highway was completely redeveloped in the early 21st century, beginning a new stage of Mount Prospect history.

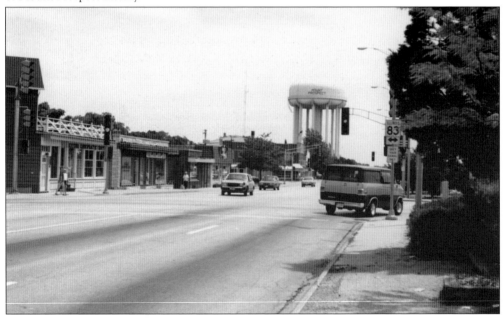

The water tower (at right) and the Mount Prospect Civic Events sign (below) are two long-standing landmarks along Northwest Highway. A water tower has stood on the corner of Northwest Highway and South Maple Street since the 1920s. The current water tower replaced the old one in 1956, and this photograph shows the new tower shortly after its completion. Its increased capacity helped accommodate growing water usage from newly subdivided neighborhoods. Since then, the water tower has been painted for various events, like milestone anniversaries. For decades, the civic events sign stood directly underneath the water tower, as shown in this photograph from the 1970s or 1980s. In 1993, the Lions Club dedicated a new sign farther down the road at the intersection with Route 83 in honor of their late member Jack Meske.

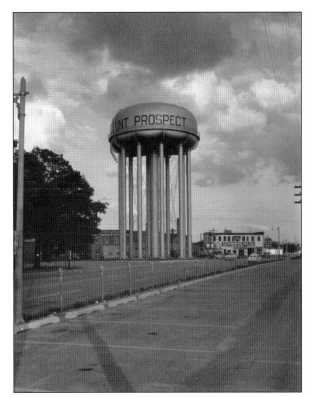

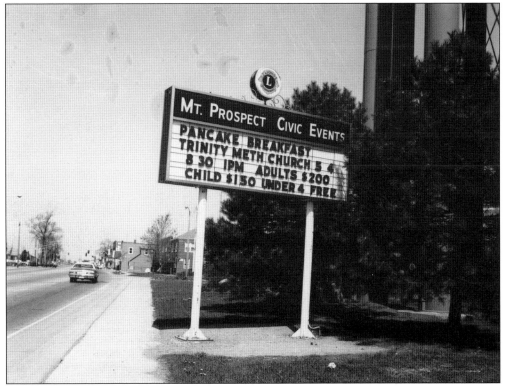

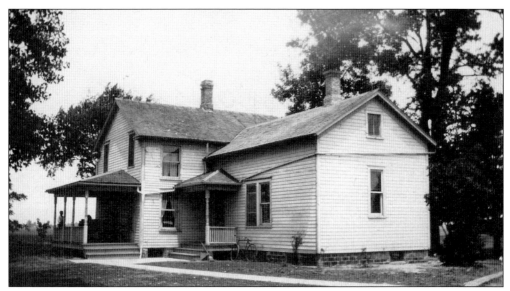

The Owen Rooney House on South George Street is the oldest home in Mount Prospect. Owen Rooney, a farmer, arrived in the area in 1847, and the house was constructed some time in the mid-1800s. It is pictured here around 1917, a year after the Busse family purchased the home and farm. Part of the Rooney property was subdivided in developer Ezra Eggleston's 1873 map of Mount Prospect, and the rest of the farmland became the Busse Eastern Addition in the 1920s. Each successive owner of this farmhouse left their own mark on the structure. The dramatic changes are evident when comparing the 1917 photograph (above) with the picture from the 1970s (below). Rooney passed away in 1877, but his name lives on in the community—both Owen Street and Owen Park are named after him.

Three

BITS AND PIECES

Mount Prospect has changed dramatically since its incorporation as a village in 1917. Decades of population booms and economic shifts contributed to a changing landscape, and with that change often came new buildings that took the place of older ones. Some of these old buildings were particularly meaningful to the community, and as a result, community members had the foresight to save pieces of the structures during demolition. These relics offer an important connection to moments of the past and the memories associated with the connected site. Some of them have become part of the Mount Prospect Historical Society artifact collection in order to keep them preserved and available to share with the community. Some became commemorative items, while others still remain hidden around town. This chapter discusses some of the demolished buildings of Mount Prospect and the bits and pieces of them that remain.

St. Paul Lutheran School was established in 1913, four years before Mount Prospect was incorporated as a village. The church and school communities increased so rapidly that by the late 1920s, the school had grown out of two buildings and needed a third. Chicago architects R. Harold Zook and William F. McCaughey designed the new school. These architects were well known during the 1920s for their Art Deco style, especially around the suburbs of Chicago. They also designed Mount Prospect's second Central School, the Pickwick Theater in Park Ridge, and various private homes. Their plans often highlighted decorative brickwork, and in the St. Paul School building, that feature is visible in the series of triangles near the top of the structure in this 1942 photograph. St. Paul students began attending classes here in 1928, and generations of alumni have fond memories of their school days.

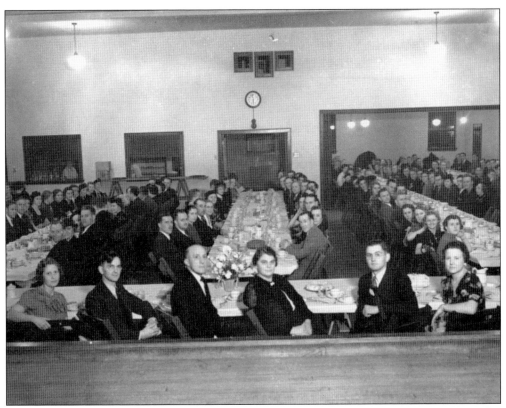

One of the highlights of the third St. Paul School building was the third-floor auditorium. This photograph of a celebration in the 1930s or 1940s shows the spacious room. The fully equipped kitchen is visible in the back at left, and the adjoining room is open for more diners. Seated at the head table are, from left to right, Rose Hasz, Martin Hasz, Rev. J.E.A. Mueller, Sophie Mueller, Wilbert Busse, and Helen Seegers.

As Mount Prospect and St. Paul School grew during the population boom of the 1950s and 1960s, it again became necessary to expand the school. This addition was constructed in 1956. Here, longtime St. Paul pastor Rev. J.E.A. Mueller is blessing the cornerstone just before it was placed in the nearly completed school building.

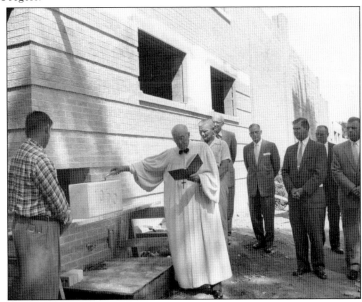

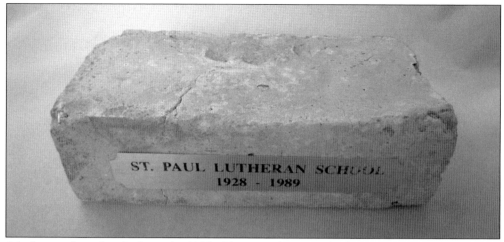

A little over three decades later, the 1956 addition to the St. Paul School needed space for another addition, so in 1989, the 1928 school building was demolished. Bricks were salvaged from the demolition site, and former students could purchase a piece of the building. This commemorative brick in the Mount Prospect Historical Society collection was donated by a St. Paul alum. Interestingly, the brickmaker's fingerprints are visible near the top edge.

Throughout the 1940s, the Mount Prospect Lions Club hosted an annual fall festival on the corner of Main Street and West Prospect Avenue, a parcel of land that was once part of George Meier's farm. Festivalgoers enjoyed food, displays from local businesses, and raffle prizes. Residents also entered homegrown produce and homemade goods into competitions. This photograph highlights the award-winning flowers, vegetables, and preserves from the 1948 festival.

Construction began on the Park and Shop with an official ground-breaking ceremony in May 1950 on the site of the fall festival grounds. The structure was an exciting addition to downtown Mount Prospect. In fact, the February 1950 issue of *Realty and Building* magazine praised the design as "one of the most modern and unusual store developments in the entire Chicago area." Some of the first Park and Shop tenants—including Brunberg's Five and Dime, the National Food Store, and McMahon's Dry Goods—opened for business in the fall of 1950. The entire block of stores was completely full by 1952. Keefer's Pharmacy, Mary Jayne's Ladies Apparel, and Sam's Place all arrived later, but each one stayed at the Park and Shop for over 40 years. This image shows the Park and Shop a few years after it opened.

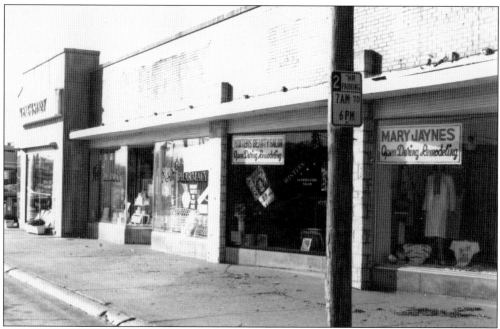

The Park and Shop received a new look and a new name in the mid-1980s as part of the village's Façade Improvement Project. The modern improvements helped the Park and Shop compete with newer shopping centers, like Randhurst, on the outskirts of town. In this photograph, remodeling work is already underway for Keefer's Pharmacy, Winters Beauty Salon, and Mary Jayne's Ladies Apparel.

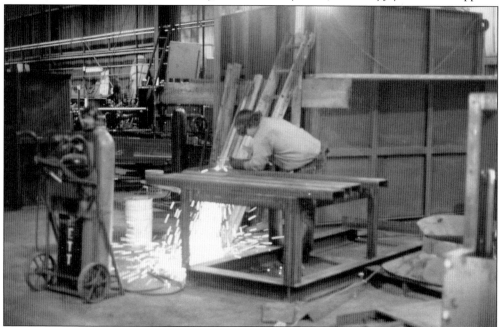

One major change made to the Park and Shop in the 1980s remodel was an arch added across the central driveway that replaced the original neon Park and Shop sign. At the suggestion of Penny Weinberg, wife of property manager Mike Weinberg, a clock was placed in the center of the arch to add a focal point. Sparks are flying in this photograph as a man fabricates the iconic arch.

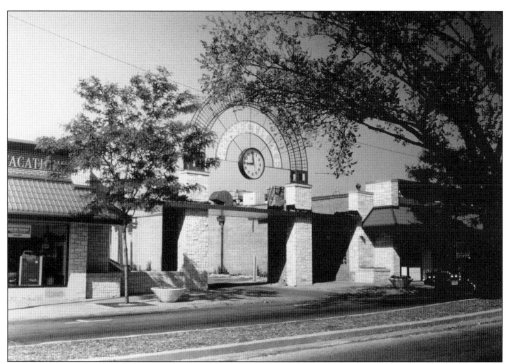

With a new look also came a new name for the Park and Shop. The property manager and village representatives held a contest for local children to choose the structure's new name, and "Prospect Place" was the clear winner. This photograph, taken shortly after the project was completed, highlights the building's new appearance.

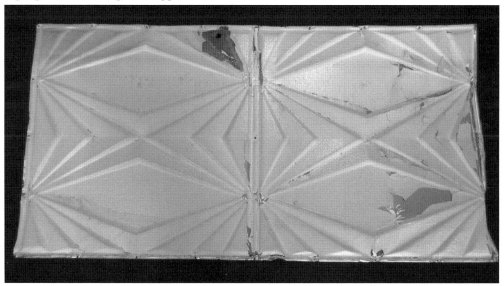

The property owners sold Prospect Place to developers in early 2020, and the structure was demolished in September 2021. This piece of a decorative tin ceiling was salvaged from one of the storefronts. By that time, most of this decoration had been hidden in back rooms or covered by modern ceiling tiles. The iconic arch and clock were saved and are in storage at a public works facility awaiting a future use.

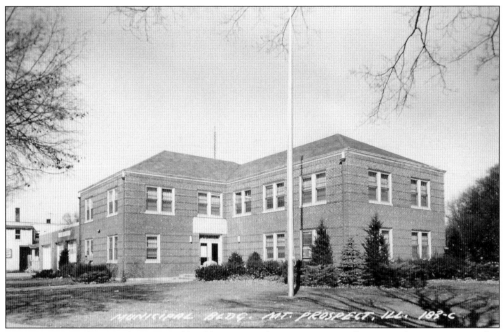

Mount Prospect's second municipal building opened at 112 East Northwest Highway in 1949. This was the town's first freestanding municipal building and a point of pride for the community. The first municipal building had been attached to the Crowfoot factory. A photograph similar to this one was used in Mount Prospect Chamber of Commerce directories for years.

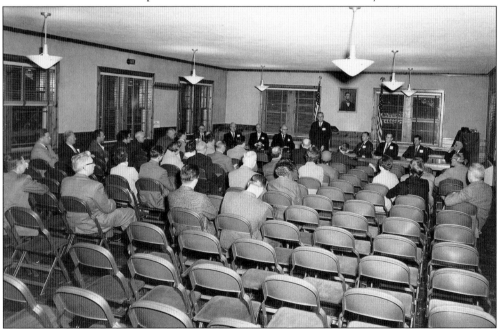

The 1949 municipal building was an important asset to Mount Prospect as it experienced a population boom in the 1950s and 1960s. It offered more space for meetings and a more polished, professional image that became helpful in attracting more residents to the town. Mayor Theodore Lams stands to make a comment in this 1950s photograph of a village meeting.

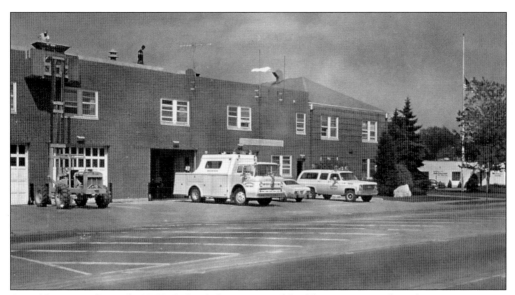

An addition in the early 1960s helped the municipal building accommodate the ever-increasing demands of a rapidly growing town. However, the village outgrew the space by the mid-1970s, and all departments except the fire and police departments moved into the former Mount Prospect State Bank building and the former public library building on nearby Emerson Street. Fire trucks await the next call outside the station in the 1970s picture above. Both departments shared this space until they outgrew it. The former municipal building was demolished in 1991 and replaced with the new Police and Fire Headquarters, sometimes referred to as the Public Safety Building. The below photograph shows a speech during the ribbon-cutting ceremony, held on October 2, 1993. Alice Teichert, wife of former mayor Robert Teichert, cut the ribbon in honor of her husband's dedication to the village.

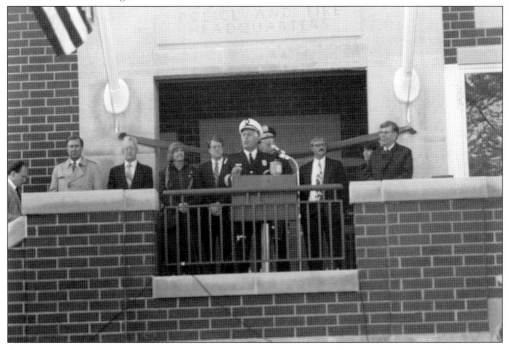

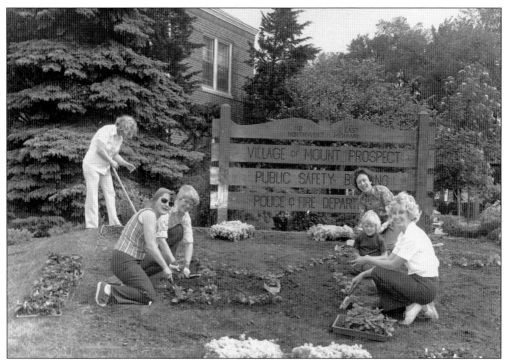

The Public Safety Building's location along Northwest Highway made it ideal to showcase landscaping. Here, members of the Garden Club of Mount Prospect are preparing the flowerbed for bicentennial celebrations. Sally Viger is standing in the back, and kneeling at left are Carol Alcoe (front) and Rachel Toeppen (back). At right are Joan Barker (back) and Janice Grover (front). The small child in between is possibly Grover's daughter.

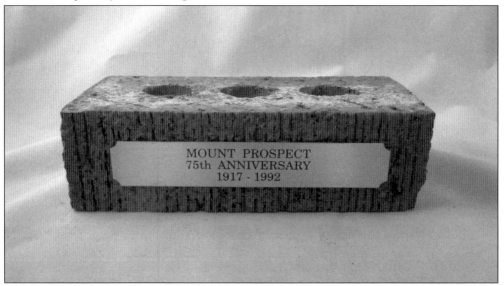

The second municipal building was demolished in July 1991. Members of the village's 75th Anniversary Diamond Jubilee committee recovered many of the bricks from this beloved building and sold them to raise funds for the following year's festivities. Each brick had a commemorative plate on the surface and included a certificate of authenticity.

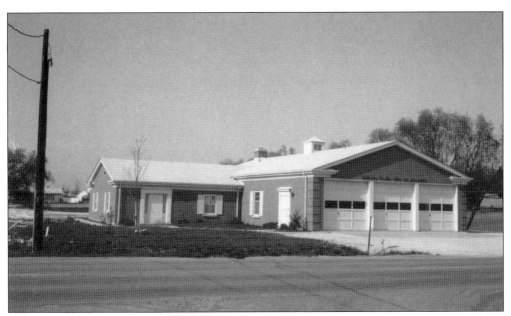

In 1965, the Forest River Fire Protection District constructed a brick station for its volunteer fire department near 2000 East Kensington Road. This small station was originally intended to be a temporary facility for the crew, with plans to replace it as early as 1971. Those plans changed, however, when the Village of Mount Prospect annexed the community in 1972. Incorporation into Mount Prospect halted plans for a new station, but it also made the firefighters and paramedics part of a full-time department with paid positions. The photograph showing the closed garage was likely taken before annexation, and the photograph showing parked fire trucks was taken after annexation. The garage is labeled Station 3 in the more recent photograph, but the station was later renumbered Station 14. (Both, courtesy of Jim Miller.)

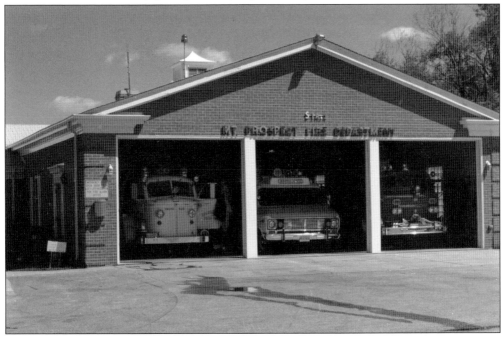

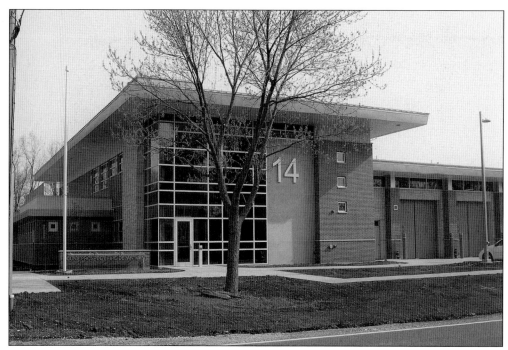

This "temporary" Station 14 structure was replaced with a new, state-of-the-art station in 2010. In May of that year, the Mount Prospect Historical Society cohosted a firehouse preview party to celebrate the new station. Proceeds from the event went toward Central School renovations, since the Mount Prospect Fire Department began in that historic building in 1913. At the party, in addition to taking tours of the new station, guests were treated to entertainment and a firehouse-style dinner of chili, hamburgers, and hot dogs. Bidders could win fire truck rides to work or school or a ride during a Mount Prospect parade. Guests could take home a piece of the 1965 station with commemorative bricks like the one shown below.

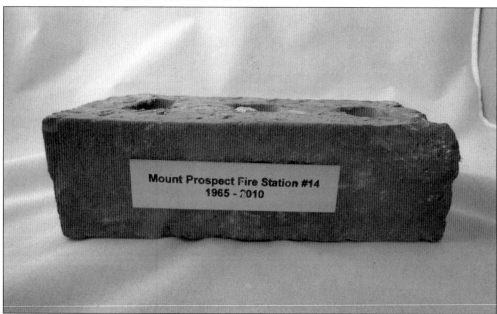

Mount Prospect Fire Station #14
1965 - 2010

Richard Huecker opened one of the first service stations in Mount Prospect in 1917. In the 1930s, he moved the business from Northwest Highway to a garage on the corner of Central Road and Main Street. The 1950s aerial image above shows that building at center left. Across Central Road are Charles Homeyer's greenhouses, and across Main Street is Central School. Richard's son, Norb, eventually took over the management of the service station. Norb developed a reputation for personal service and going above and beyond for his clients, many of whom were longtime customers. In 1969, he built a new station, which is pictured below from across the street in 1975. The Village of Mount Prospect purchased the service station property from Norb in 1999 as part of downtown redevelopment plans, so he closed the station and retired.

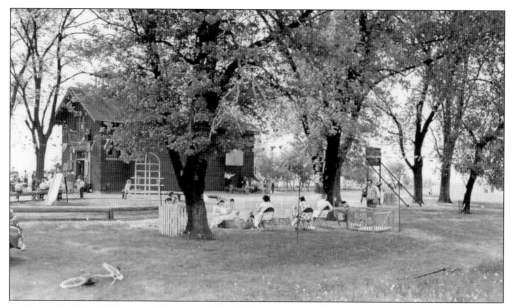

Feehanville School District 26 was established in 1895. Students attended the first Feehanville School, a one-room schoolhouse, at the intersection of River and Kensington Roads. By the 1920s, this land had become part of the forest preserve, so the building was moved to a local farm. In 1922, the district built this two-room brick structure on the 1400 block of Kensington Road, which is shown here in the 1950s.

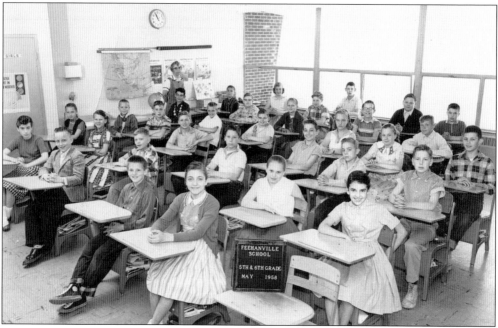

Feehanville School and its District 26 were on the cusp of many changes when this fifth- and sixth-grade class photograph was taken in 1958. Beginning in 1961, District 26 constructed five new schools and changed its name to River Trails School District 26. However, student enrollment declined in the following decades. Three schools, including Feehanville School, closed because of this shift. (Courtesy of John Armstrong.)

Feehanville School was demolished and rebuilt in 1967 in order to better serve the rapidly growing number of students in the district. The school's bell was saved and stored. In 1973, the community funded a monument for the bell, which now stands outside River Trails Middle School. A plaque was added to the monument in 1995—the year of the district's centennial—to honor those who helped create the district.

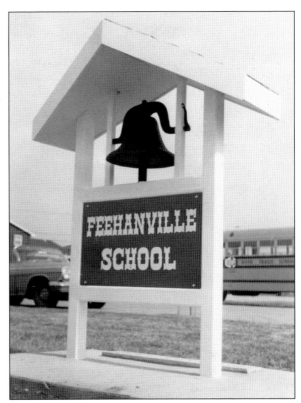

What appeared as one long Tudor building along Main Street was actually several buildings connected by a unified facade. The oldest of these buildings was Louis C. Busse's general store, which dated to around 1897. Between 1926 and 1927, Louis's grandson, William Busse Jr., constructed an addition and the facade. These construction workers paused for a photograph. William is standing in the center at street level.

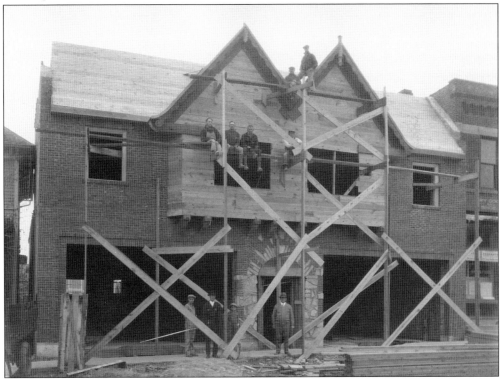

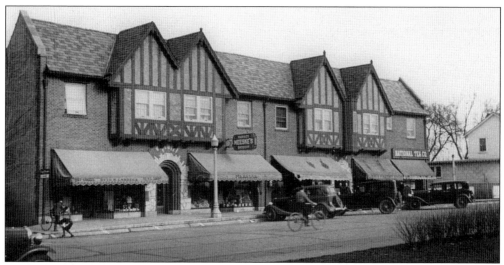

This series of buildings was a modern addition to Mount Prospect. Not only was Tudor-style architecture popular at this time, it also expanded the downtown business area. Some early stores visible in this 1930s photograph include Bohm's Pastry Shop, Meeske's, and the National Tea Company. Importantly, the increased retail space helped accommodate new residents arriving in the quickly growing community.

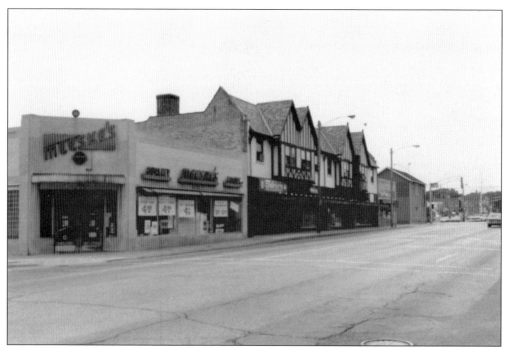

Over the years, Main Street buildings became important local landmarks. Popular businesses like Meeske's, the Gift Box, and Sakura Japanese Restaurant had storefronts here. The Mount Prospect Chamber of Commerce also had a home here in the 2010s. This photograph captures Main Street at a quiet moment during the 1970s or 1980s. Sakura is located in the Tudor-style storefront at far left, and Meeske's had already moved to the building next door.

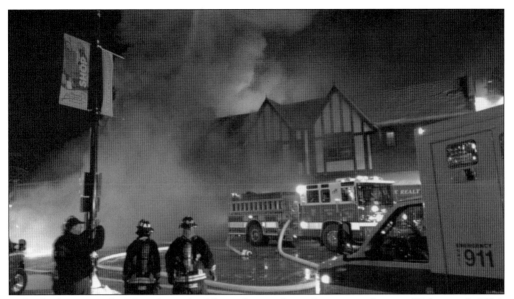

A fire broke out in the Main Street buildings during the early morning hours of February 9, 2014. Mount Prospect firefighters had to call for assistance from 13 neighboring towns in order to quench the blaze. Although no one was injured, the structure was badly damaged and could not be saved. The building was demolished later that year. (Courtesy of Chad Busse.)

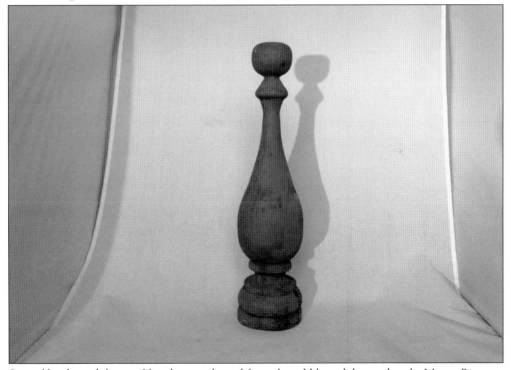

Several bricks and this roof finial were salvaged from the rubble and donated to the Mount Prospect Historical Society. The finial is made of painted wood but is not original to the structure. It was likely added during the Façade Improvement Project in the mid-1980s. It is in excellent condition, especially considering its exposure to the elements, smoke, and water.

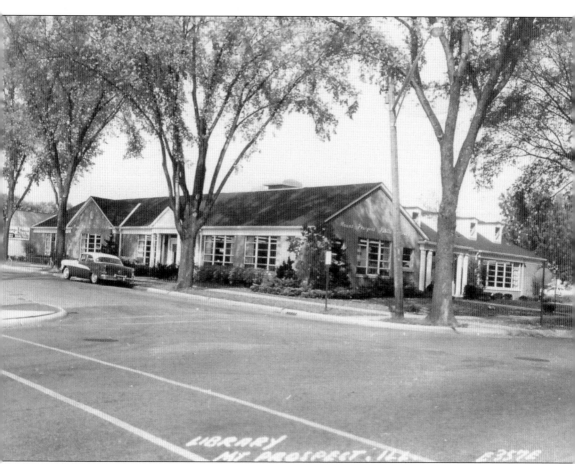

The Mount Prospect Public Library building pictured on this postcard in 1950 was a huge improvement from the library's first home in the cloakroom of the one-room Central School in 1930. That first library collection contained about 300 books and was entirely financed with donations that the Mount Prospect Woman's Club had gathered in 1929. The library continued to expand and first moved to the former Mount Prospect State Bank building on Main Street and Busse Avenue and then to a storefront farther down Main Street. This humble beginning made the 1950 library building an exciting addition; it was the first purpose-built library in Mount Prospect. Community donations and a bond referendum allowed the library to purchase the land on the corner of East Busse Avenue and South Emerson Street. The larger space provided more resources for the town's growing population.

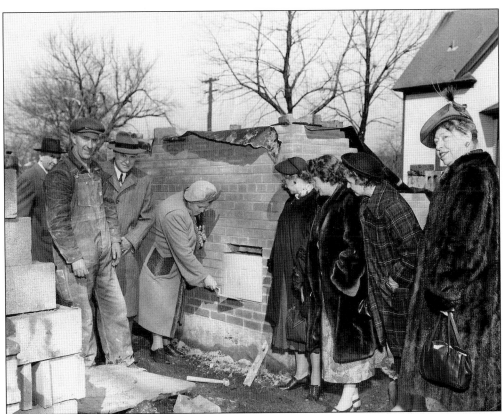

Village and library representatives gathered to lay the cornerstone of the new library on March 24, 1950. They added a time capsule to commemorate the occasion. Some of the items placed inside it included the covers of current books, a list of donors, and an article about the library's beginnings. Here, Dorothy Kester, library board president, sets the cornerstone while surrounded by library and village officials.

About 10 years after the library opened, it needed an addition to keep up with the growing number of patrons. That expansion was completed in 1962. This photograph dates to around that time and shows the stacks crowded with both patrons and librarians. There were around 30,000 volumes in the library's collection when this picture was taken.

Mount Prospect outgrew the 1950 library building by the 1970s, so the library purchased new property on the opposite side of the block. That new building was dedicated on January 23, 1977. The former building became the Village of Mount Prospect Senior Center, as well as home to the village's human services department and local television services. This photograph shows the senior center not long before it was demolished in 2002.

After the 1950 library building was demolished in 2002, the cornerstone made its way to the Mount Prospect Historical Society's artifact collection. The contents of the time capsule hidden in the block were revealed in a ceremony later that year. In 2004, a new village hall was constructed on the site next door to the 1977 library building.

This distinctive red-and-white house, pictured in 1964, once stood on the Russel farm at 211 West Kensington Road. Hans Heinrich Russel immigrated to the United States in 1849 and cultivated the land between Kensington and Central Roads. In 1918, the farm was sold, and the H. Roy Berry Company subdivided the property in the 1920s. A street near the farmhouse was named after the Russel family.

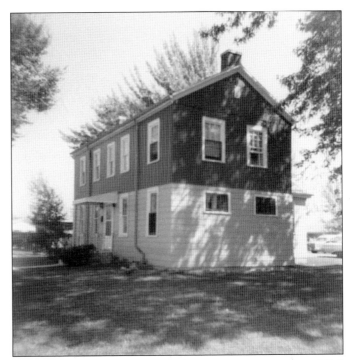

The Russel farmhouse fell into disrepair as redevelopment was halted due to the Great Depression and World War II. The Atwood family moved into the house in the 1940s and repaired it. After almost 40 years in residence, Margie Atwood made this dollhouse replica, fulfilling a childhood dream. The full-size house was destroyed in a fire in 2001, making this dollhouse all that remains of the beloved home.

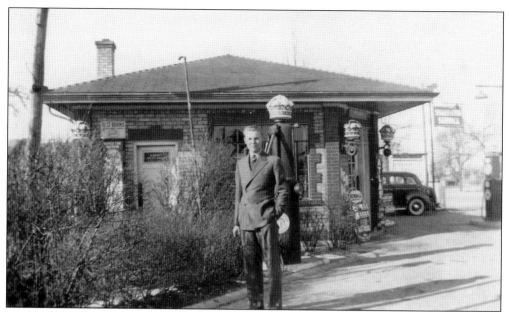

In 1927, Uptown Standard Service Station opened in the heart of downtown Mount Prospect on the corner of Northwest Highway and Main Street. John P. Moehling, son of the owner of Mount Prospect's first store, built this service station to serve the growing number of cars in the area. This photograph shows John P. Moehling Jr. outside the station during the mid-1930s.

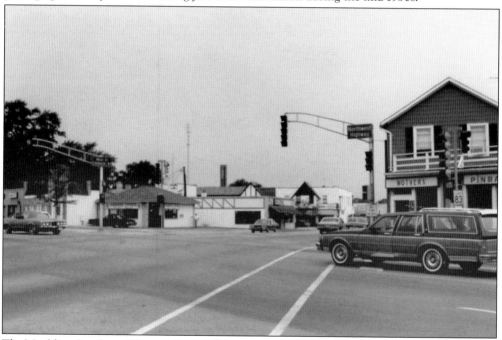

The Moehling family ran Uptown Service Station for years before eventually selling the property to other owners. The creation of expressways in the 1950s made this location a less ideal spot for a gas station than it had been in the late 1920s. In 1981, George and Dee Zoumaras opened Submarine Express, a sandwich shop, in this same building. This photograph captures the restaurant shortly after it opened.

George and Dee Zoumaras's son Tom eventually began managing Submarine Express. Over its almost 40 years in operation, it became a local favorite for both the food and Tom's friendly customer service. He helped community organizations raise funds with dine and share nights and assisted the village food pantry by storing food left over from the Lions Club's weekly farmers market. In addition to its highlighted submarine sandwiches, the restaurant served burgers, varieties of hot dogs, Polish sausage, and salads. Submarine Express closed in 2020. These images show the interior and exterior of Submarine Express on one of its last days in operation. (Both, courtesy of Jean Murphy.)

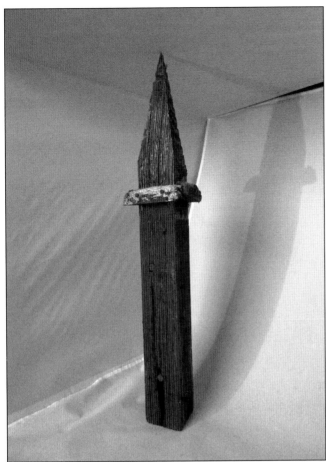

In March 2021, this nearly 100-year-old building was demolished. Several bricks and a roof finial were recovered during the demolition. The finial shown here was part of the Tudor-style elements added to the structure in the mid-1980s as part of the Façade Improvement Project. This project gave a more cohesive appearance to downtown Mount Prospect.

William Wille started a family legacy when he began selling cheese in 1880 at the intersection of Northwest Highway, West Busse Avenue, and South Wille Street. He stopped selling cheese in 1902, and his sons began selling farm and building supplies at Wille Lumber and Coal. These products were essential in the building of the early Mount Prospect community. The brick office building of Wille Lumber and Coal, constructed in 1917, reflected the business's significance in the community.

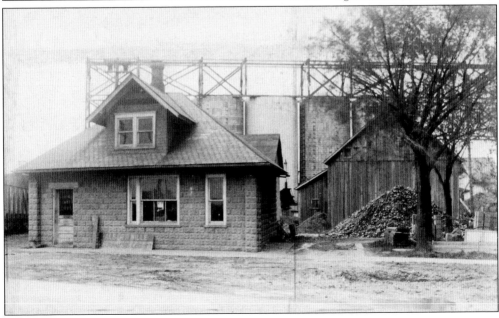

The Wille family adapted product offerings as the community around them changed from a small farm community to a bustling suburb. By the 1950s, Wille Lumber and Coal was selling hardware and houseware items as well as sports equipment and gifts. To keep up with the growing population, the business's facilities were expanded several times. This photograph shows the 1940 building with a wide roof and the rectangular 1958 addition behind it.

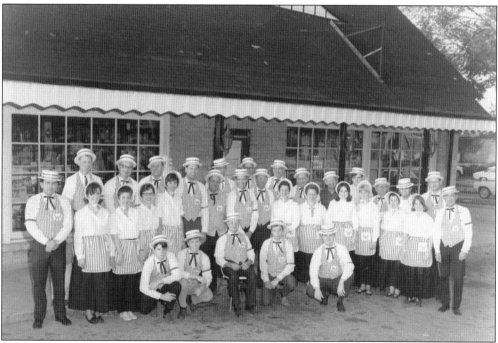

Albert Wille's sons, Roy, Ralph, Robert, and William, all joined him in running Wille Hardware, as it was later called. This photograph of the extended Wille family shows Albert, one of the business's founders, seated in the center and surrounded by his family. It was taken some time before Albert passed away in 1968.

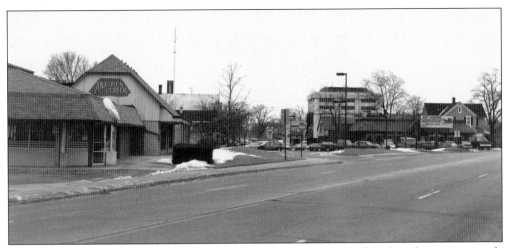

Wille Hardware faced steep competition from national businesses and had to close permanently in January 1976. The building was used by other businesses in the following years, including Antiques Center of Mount Prospect. This establishment moved to Mount Prospect in 1986 and consisted of booths for 35 antiques dealers. It is pictured on the left in this late-1980s photograph of Northwest Highway.

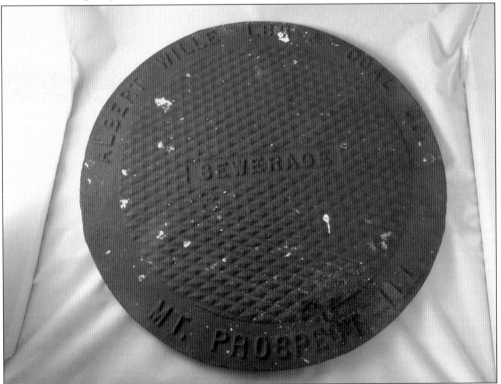

The Wille Lumber and Coal structure was demolished in the early 1990s to make room for a condominium and strip mall development, but this manhole cover was salvaged from the site. It likely came from an inspection manhole that connected to the village's sewer system. It is unique because it is labeled "Albert Wille Lumber and Coal Company"—the original name of the Wille family business.

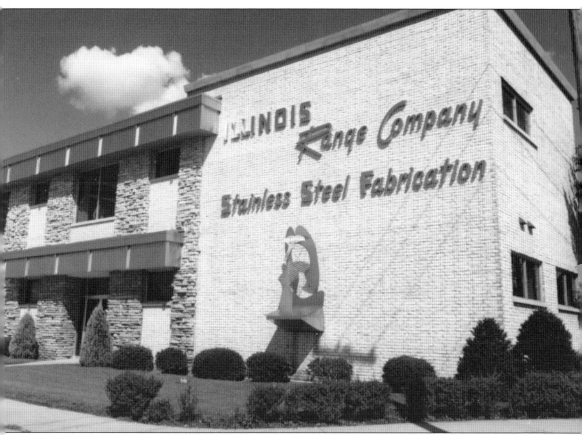

Illinois Range Company (IRC) moved to Mount Prospect in 1944, settling along West Central Road. This business was known for its stainless steel food service industry products, which included items such as serving and food preparation counters, sinks, and hoods. One famous customer was McDonald's, which used IRC products in some of its first restaurants. Philip Jeuck, the owner of IRC, also donated equipment to two Mount Prospect churches: St. Raymond Catholic Church and St. Mark Lutheran Church. Philip was Catholic, and his wife, Marie, was Lutheran, so these were fitting donations. Though IRC moved farther down Central Road in the 1990s, it remained in town until it was sold in 2001. Longtime residents might remember the miniature stainless steel Picasso sculpture perched outside the building since 1971, which is pictured here. The company's engineering team originally built the one-seventh-scale model for the National Restaurant Show in Chicago.

Although Illinois Range Company is no longer in operation and the Picasso sculpture was lost, it has literally left its mark on the community. The company set this stainless steel "1963" in the sidewalk east of the entrance the year before it expanded its facilities. A stainless steel "JK" (not pictured) is set into the opposite side of this sidewalk block.

When the old Chicago Federal Building was demolished in 1965, interested parties were allowed to take pieces of the structure as long as they could remove the pieces. Joseph Koenen, project engineer for Kenroy Development, acquired three columns and a capstone for Huntington Commons. This mid-1970s aerial view shows the columns and capstone in their new location, rising dramatically out of the Huntington Commons lake.

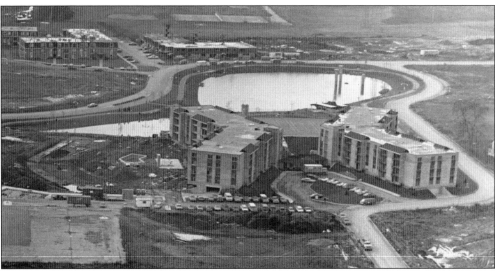

Four

COLLECTIVE MEMORY

Some Mount Prospect sites had such a powerful presence in the community that their existence in the collective memory lasted long after their physical structures disappeared. One of these unique areas in town is the small downtown triangle, which has undergone dramatic redevelopment since 2000. Other memories center around working, eating, or simply having fun in various places around town. This chapter focuses on some of the places in Mount Prospect for which there are no physical remnants but rather just the reminders living in residents' memories.

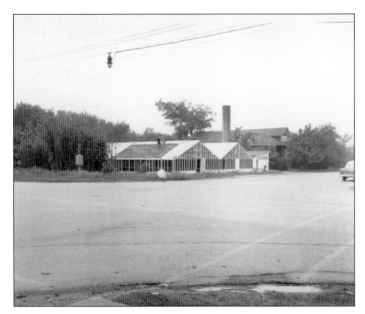

Charles Homeyer opened greenhouses at Main Street and Central Road in the late 1920s, becoming one of several florists in Mount Prospect. Homeyer was active in the community, and his greenhouses even served as an election polling place. When the Homeyers moved to Wisconsin in the 1940s, William McReynolds began operating Hook's Nursery on the site. This photograph shows the greenhouses in the late 1950s, after Hook's Nursery had moved.

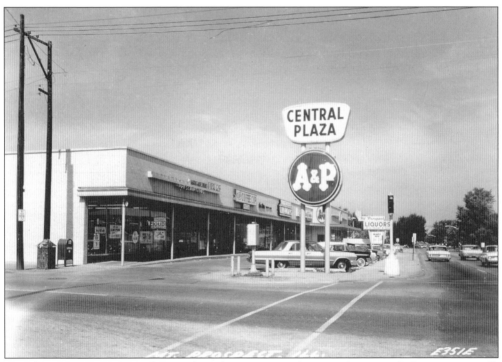

Hook's Nursery moved to Lake Zurich in the 1950s to make room for Central Plaza, a strip mall. Its grand opening was held on March 17, 1959, and the highlight of this new shopping center was the A&P store. Over the years, many other favorite local businesses came and went, including Doretti Pharmacy, House of Szechwan restaurant, and Mane Street Salon. This postcard shows Central Plaza during the 1960s.

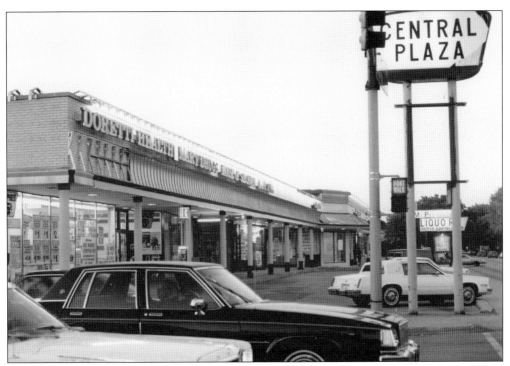

Despite much-needed renovations during the 1980s, nearly half of the storefronts in Central Plaza were vacant by the 1990s. It became an unfortunately prominent eyesore, but unresolved questions of property ownership prevented any renovations or development. The structure was demolished in 2015, and the Village of Mount Prospect acquired the property through foreclosure. This photograph captured Central Plaza near the end of renovations in the 1980s.

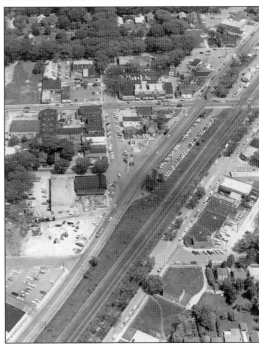

Mount Prospect's historic downtown area is known as the Small Triangle. It was first mapped out in the 1870s and later developed by the community's four founding families. This 1962 aerial view shows the area encompassed by Main Street (at the top of the triangle), East Busse Avenue (at left), and Northwest Highway (running diagonally across the image). Wille Street meets at the tip of this triangle at the intersection of Busse Avenue and Northwest Highway.

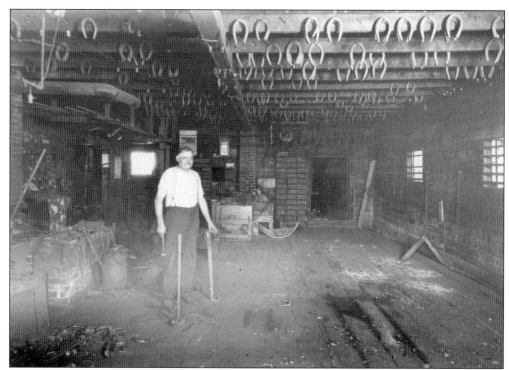

The Small Triangle was the heart of early Mount Prospect; some of the area's oldest homes were built there, and some of the oldest businesses began there. One important establishment was John Meyn's blacksmith shop, located on Main Street and Northwest Highway. Having a blacksmith in Mount Prospect made the town a viable place for farmers to settle permanently because it offered them resources that they needed to continue operations. Meyn, pictured above inside the shop around 1890, forged and fixed tools and shoed horses. John's oldest son, Herman, continued blacksmithing into the 20th century before becoming the town's second mayor. Herman is standing outside the shop in the photograph below. The family home, the third house in town, is visible behind the shop. John's second son, William, opened a grocery store on the opposite side of the Small Triangle.

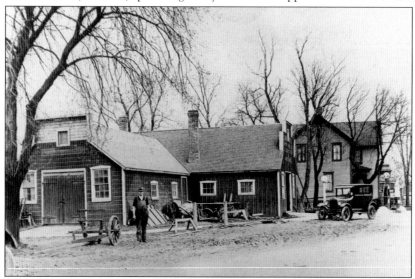

Some of the earliest discussions about redeveloping the Small Triangle began in the 1970s. By that time, shopping centers on the edges of town had drawn shoppers away from the center, taking a toll on long-standing local businesses. Traffic and parking concerns were also pressing matters. This 1977 photograph of West Busse Avenue shows the traffic congestion and inconsistent design of downtown buildings.

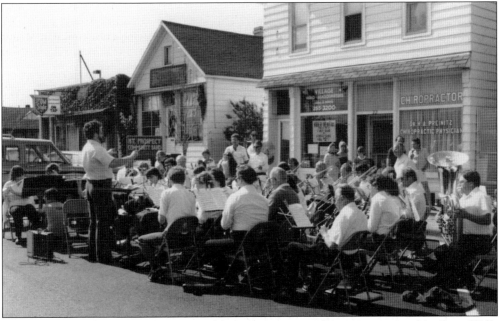

One of the first modern downtown revitalization projects was the improvement of the Busse-Wille area of the Triangle. The plan included widening sidewalks, repaving the streets, introducing lighting, and planting more landscaping. It was financed by community block grant funds and private property owners. Mayor Carolyn Krause and other dignitaries opened the revitalized street in June 1982 with a ribbon-cutting ceremony and music from the Mount Prospect Community Band, shown here.

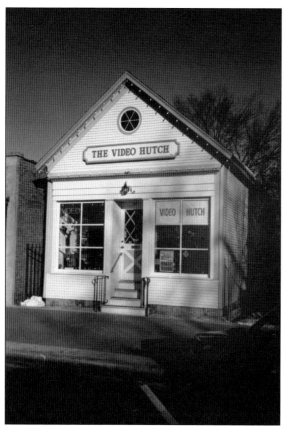

The Façade Improvement Program, introduced in 1983, was a Village of Mount Prospect redevelopment project that aimed to create a more cohesive downtown appearance and attract shoppers by upgrading storefronts. The village shared the costs with private owners. Community development director Kenneth Fritz worked with local business owners and architects to redesign downtown. The Video Hutch, pictured here with its new look, participated and was repainted light blue with beige and copper trim.

Redevelopment continued at the turn of the 21st century. This phase transformed the downtown landscape with new and upgraded buildings. Many of these projects proved controversial, however, because they displaced established businesses. One project was The Shires at Clocktower Place, a condominium complex on the former site of Wille Lumber and Coal. This photograph shows Mayor Skip Farley at the podium during the August 1994 ground-breaking ceremony.

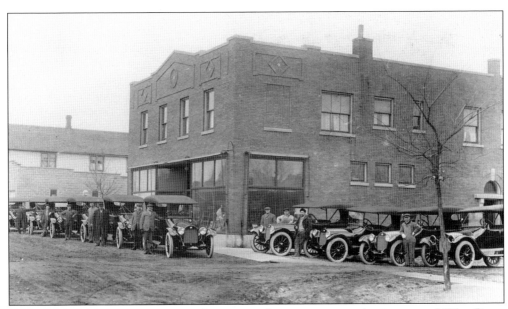

Generations of Mount Prospect residents remember visiting many businesses at 2 West Busse Avenue before it was demolished in 2006. The building was constructed in 1912 for William Busse's hardware store, but shortly afterward, it also became the office of Busse's Buick dealership. The staff posed with Buicks for this photograph from around 1915. Other memorable businesses in this location included Danneo's Ice Cream Parlor and Sammy Skobel's Hot Dogs Plus.

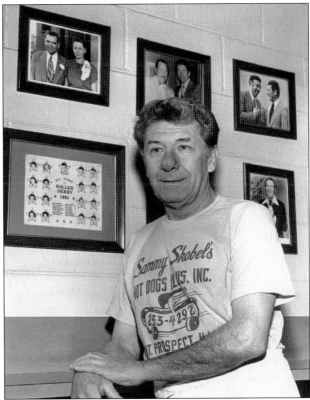

One beloved Small Triangle business was Sammy Skobel's Hot Dogs Plus, owned and operated by Sammy and Vee Skobel. It opened on Main Street in the mid-1960s after Sammy retired from a successful roller derby career. Appropriately, the logo was a hot dog zooming on skates, which is visible on Sammy's T-shirt in this photograph. Sammy and Vee's warm, welcoming personalities, as well as the food, made this restaurant a local favorite.

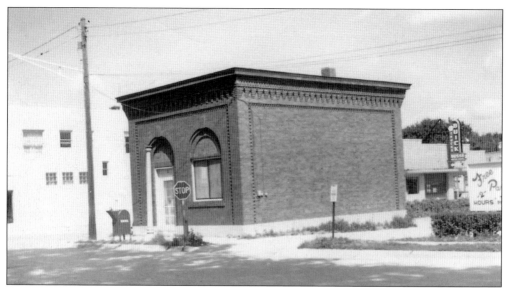

William Busse established Mount Prospect National Bank in July 1911, six years before the town was incorporated. He constructed a small building on the corner of Main Street and Busse Avenue. Local tradesmen William Wille and Dietrich Friedrichs worked on the structure, providing carpentry and painting services respectively. The building is pictured here in the mid-1950s. It was home to the public library and several other businesses before it was torn down in the 1960s.

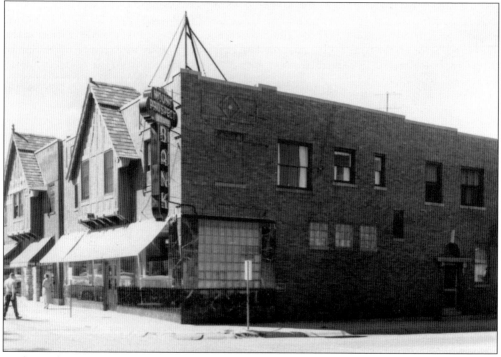

In the mid-1920s, the Mount Prospect National Bank changed to a state bank. This shift was important because Mount Prospect's population boomed during the 1920s, and becoming a state bank allowed it to better meet the community's needs for real estate loans. A few years later, the bank moved across the street to this building, formerly the headquarters of Busse Buick.

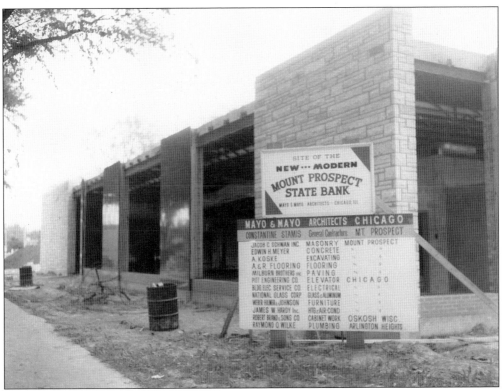

Rapid growth in town meant that the Mount Prospect State Bank eventually needed a larger space. This time, however, the bank built a new, modern structure to house its operations. The sign in this 1959 photograph of the construction site demonstrates the emphasis on "new" and "modern" elements. The completed facility, pictured shortly after opening in 1959, offered customers an innovative banking experience when compared to what they had at the previous building. There was a drive-through window, an after-hours deposit box, additional parking, and a stylish lobby. The contemporary design matched the sense of progress sweeping the rest of the town.

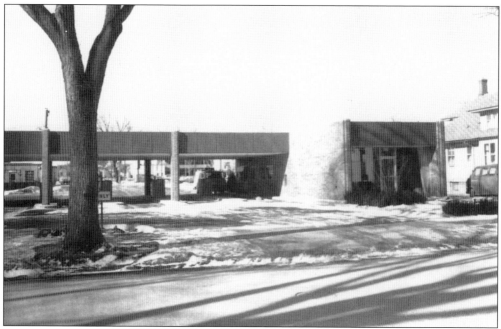

The Mount Prospect State Bank continued to keep up with the pace of the growing community. The bank installed a Burroughs B-300 electronic data system to speed up banking in a facility near the first bank building in 1968. A separate, exclusively drive-through Motor Bank opened between Emerson and Maple Streets three years later to relieve heavy traffic at the main branch. The Motor Bank, shown here that year, doubled the bank's drive-up windows.

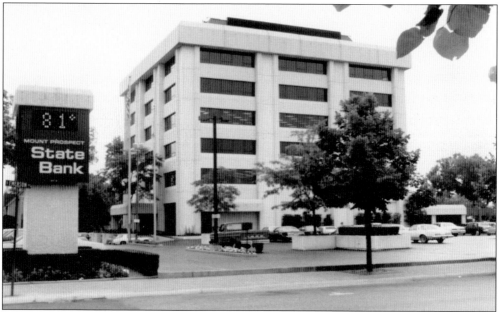

In 1974, Mount Prospect State Bank broke ground on another new building next to the Motor Bank. When it was completed in 1975, the six-story structure became the tallest building in town. This undated photograph shows how it towered over the neighborhood. Not only was this building another mark of progress for the bank, but it was also intended to begin a revival of downtown businesses.

First Chicago Bank purchased Mount Prospect State Bank in 1987. The transition did not prevent the bank from remaining active in the community. In fact, local organizations often set up tables in the lobby, and the sizeable parking lot offered a convenient space for downtown events. Throughout the 1980s and 1990s, the bank was the starting point of the historical society's annual Holiday House walks and the end point of the annual Teddy Bear Walk parade, where children welcomed Santa and Mrs. Claus. Ernie T. Bear stands at the bank's entryway in this photograph from the late 1980s. The bank's neighbor, the Mount Prospect Historical Society, also used the parking lot for its annual Antique Auto Shows in the 1990s and early 2000s. Below, a family chats with two police officers in front of another local icon, a reproduction Bluesmobile, in this photograph from the 1998 show.

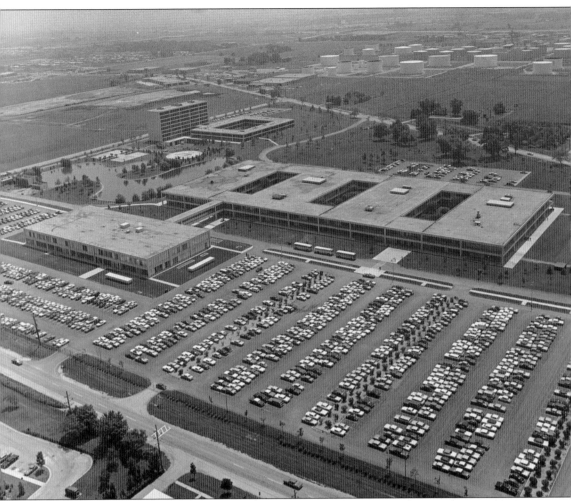

In 1961, United Airlines unveiled a new training facility for its flight attendants in Elk Grove Township, bordering the southern part of Mount Prospect. The facility provided land to grow and was conveniently close to O'Hare Airport. One highlight was the training pool covered with a plastic dome, allowing flight attendants to train year-round. The two-story executive offices, designed by Skidmore, Owings, and Merrill, opened just west of the training center in 1962. This building contained a fallout shelter that could protect 1,700 United employees in the event of a nuclear attack—a major concern during the Cold War. The United Airlines campus eventually grew to include a reservation facility, an employee hotel, and a cafeteria. This later aerial photograph shows the expansive campus. United employed thousands of area residents, and generations fondly recall working there or visiting friends and relatives who did. (Courtesy of the Elk Grove Historical Society.)

Mount Prospect annexed the United Airlines property in early 2017 after decades of periodic discussions. Later that year, United began moving the rest of its operations to its Willis Tower location, another Skidmore, Owings, and Merrill structure. By spring 2022, the entire campus was vacant, and preparations had begun for demolition and replacement with a Cloud HQ data center. This photograph shows the cafeteria before it was dismantled.

The Mount Prospect Park District's Central Community Center opened in January 2001. The name was submitted by the McPartlin family in a contest. The highlight of the recreational facility was the inline skating rink, which hosted a youth hockey league and open skate times. This photograph shows a 2005 open skate fund-raiser to benefit the Mount Prospect Historical Society's restoration of the one-room Central School. The rink was converted to a turf field in 2021.

Mount Prospect is proud of its tree-lined streets and Tree City USA recognition. Robert B. Zilius captured a picturesque archway created by overhanging tree branches down this street in the mid-20th century. With the arrival of Dutch elm disease around the same time, however, many archways were interrupted by the removal of infected trees. Since then, the Public Works Forestry Division has worked to replace the elm tree canopies with a variety of other species.

Miniature golf arrived in town with the opening of Charles Bartmann's Skil Golf Putting Courses, later called Twin Links, on Rand Road in July 1964. This advertisement from the *Arlington Heights Herald* from that month highlights its weekly Kiddies' Day special. Each 18-hole course entertained golfers with mechanical obstacles such as a musical schoolhouse. The owners added batting cages in 1978. Twin Links closed in 2006 and was replaced by a medical center.

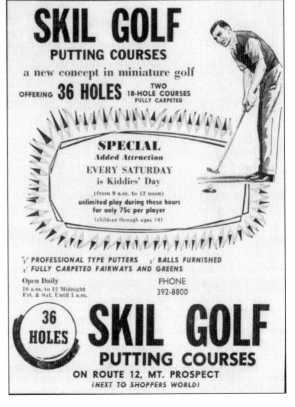

Many Mount Prospect residents remember sending mail at the post office located at 202 East Evergreen Avenue, near the water tower. This branch opened in March 1957. Cathy Ann Wooten, granddaughter of assistant postmaster Lawrence Hodges (at far right), cut the ribbon during the dedication ceremony. Postmaster Joe Knuth holds the ribbon to her left, and the other man holding the ribbon is likely John Naser, district manager.

Of all the restaurants at 113 South Emerson Street, one of the most beloved was Evan's. John Komotos opened the restaurant in 1964. Longtime residents may remember sharing family meals and hosting events there over its approximate 30 years in business. The sign pictured here was replaced shortly after this photograph was taken during the Façade Improvement Project of the mid-1980s. The building currently houses Emerson's Ale House.

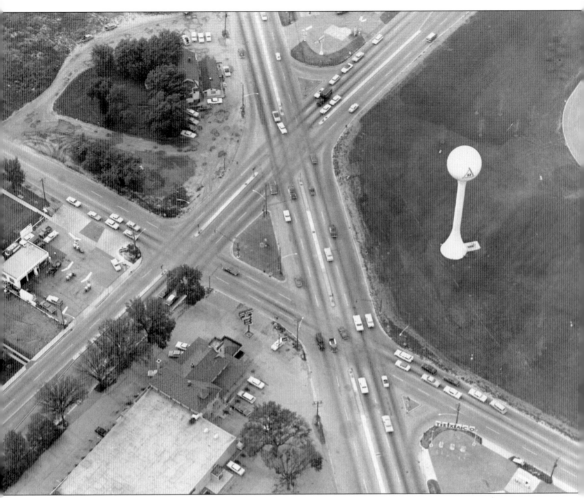

This aerial image shows the busy intersection of Rand Road, Kensington Road, and Route 83 in 1963. The building at lower left had been a popular spot for dining and events since Rand Tower Restaurant opened in 1925. Steve Sobie purchased that property in 1941 and renamed the establishment Sobie's Café. Longtime residents best remember Gunnell's Restaurant and Bowling Alley in this building. Jack Gunnell bought the restaurant in 1955 and continued the tradition of serving good food and offering ample space to gather for special occasions. Guests attending the Randhurst Shopping Center barn-burning ceremony in November 1960, which marked the beginning of construction, met at Gunnell's for lunch afterwards. Outside of special events, many who grew up in the 1950s and 1960s fondly remember bowling there or watching their parents play in the league. Gunnell sold the restaurant and bowling alley to L. Fish Furniture Company in May 1969, and he passed away two months later. Gunnell had also owned El Rando restaurant, the building at the top of the photograph partially obscured by trees.

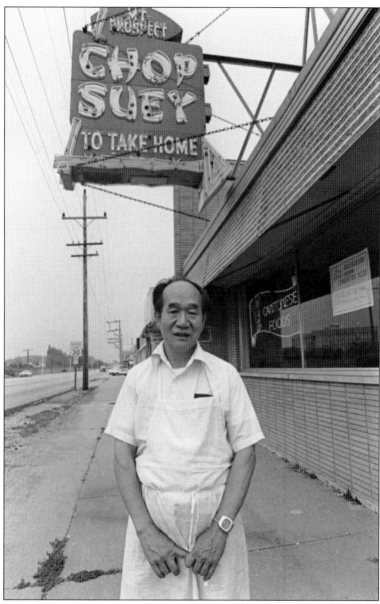

Kenneth and June Gong opened Mount Prospect's first Chinese restaurant, Mount Prospect Chop Suey, in October 1959. A crowd of customers arrived on opening day, and the restaurant quickly became a local favorite. Kenneth, a World War II veteran, borrowed money to start the restaurant and purchase the small building located near the intersection of Northwest Highway and Central Road, which needed to be converted to accommodate a take-out restaurant. They installed a neon sign in the window that featured a chef and the words "Cantonese Foods." Mount Prospect was an ideal place for a new restaurant, because the town was quickly growing. Kenneth and June were actively involved in running the restaurant. They hand-chopped all the vegetables for decades before buying an industrial slicer, and June always hand-washed the rice before cooking it. The couple retired in 1985 and sold the business to another local Chinese family with children. This photograph shows Kenneth outside Mount Prospect Chop Suey in 1984, not long before his retirement. The business closed in 2006. (Courtesy of the *Daily Herald* and Helen Gong Weiner.)

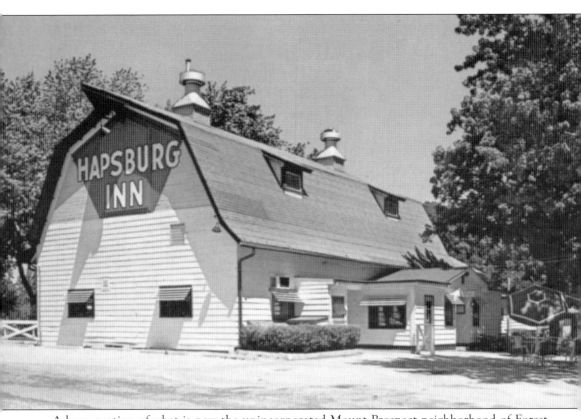

A large portion of what is now the unincorporated Mount Prospect neighborhood of Forest River was once the Coons-Nagel Farm. The Coons and Nagel families farmed the land from the mid-1800s until it was subdivided into lots for homes during the mid-1930s. In 1934, William Bahnmaier and his wife purchased a barn on this farm and opened the Hapsburg Inn inside it. This German American restaurant, located at 600 River Road, had a bar, a dining room, an outdoor beer garden, and a covered porch with a wishing well. Those who dined there have fond memories of family dinners held before the restaurant closed in 1984. This postcard shows the restaurant in the mid-20th century. The Ox-Yoke Farm restaurant occupied the barn for a couple of years until it was replaced by Kathryn's Banquets. For almost 20 years, locals enjoyed hosting weddings, showers, and other events at Kathryn's. The owners retired at the end of 2004, and the barn was replaced by townhomes.

Frank Parks Sr. and Paul Spiewak opened the first Century Tile and Supply Company store in Chicago in 1947. The Mount Prospect store, located at the corner of Rand and Central Roads, was the first suburban location and became a fixture in the community. Parks, Spiewak, and their children and grandchildren ran the business until all locations closed in 2021. This photograph was taken during the company's final liquidation sale. (Courtesy of Jean Murphy.)

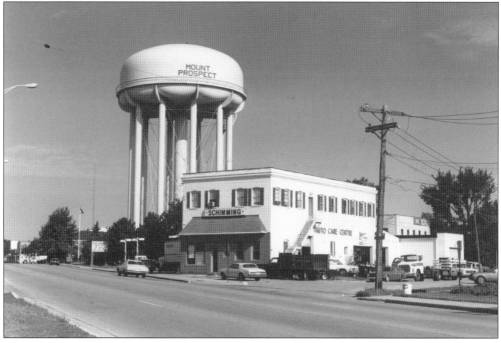

The Mount Prospect Creamery building on Northwest Highway, near the water tower, was converted to a fuel service station in 1928 when Wolf Coal and Oil company moved in. Other fuel companies replaced it over the years, including Mount Prospect Oil Company and Braun Brothers Oil Company, but most longtime residents remember driving to Schimming Oil Company, which is pictured here in 1986, shortly before it was demolished.

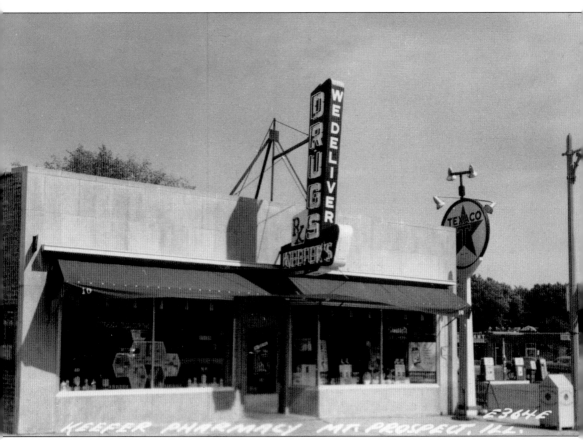

Pharmacist Jack Keefer purchased Brandt's Pharmacy on the north side of the tracks along Northwest Highway in 1949, changing the name to Keefer's Pharmacy. Over its almost 70 years in Mount Prospect, the pharmacy became an institution. This photograph shows the original building on Northwest Highway. It was known not just for its prescriptions but also for its popular penny candy counter. Many who grew up in Mount Prospect remember purchasing the candy with wooden nickels. Keefer was active in the community, even helping to establish the Mount Prospect Historical Society. In 1966, Keefer's moved across the train tracks to a storefront in the Park and Shop along Prospect Avenue. Jerry and Geri Pospisil purchased the pharmacy when Jack retired in 1976, and in 2007, Beau Diab became the new owner. In order to compete with national pharmacy chains, the Pospisils and Diab focused on compounding medications and other specialty services. Keefer's is still in business but moved down the road to Arlington Heights in 2017.

One driving force of development in 20th-century Mount Prospect was the Mount Prospect Development Association, formed in 1923 by George Busse and his friends and brothers. The real estate agency subdivided the neighborhoods surrounding downtown Mount Prospect. In 1926, the company moved to the brick building at 12 East Busse Avenue, pictured here before the name was changed to Busse Realty Association in 1937. George and his descendants George L. and George R. continued to have an active role in transforming Mount Prospect into a suburb. They were also involved in major commercial developments, notably selling the property for Randhurst Shopping Center. In 1978, the real estate agency moved to a new building at 330 East Northwest Highway, shown here the following year. Shortly after the move, they associated with Red Carpet Real Estate, becoming Red Carpet George L. Busse and Company.

The building at 15 West Busse Avenue was constructed in 1939 to be the second location of William Meyn's Grocery and Market. William was the son of blacksmith John Meyn. The new building, designed in the fashionable Art Deco style, is pictured here shortly after the grocery store reopened in 1940. After Meyn's Grocery closed in the early 1950s, many other local businesses occupied the space. One of those was Hearth and Home, which operated as OWL Appliance and Heating from 1971 until it moved to Northwest Highway; the company changed names in 1980. His and Hers Hobbies was the last business to occupy the storefront before the structure was demolished in the early 2000s. This 2006 photograph shows how significantly the facade changed over its almost 70 years on Busse Avenue.

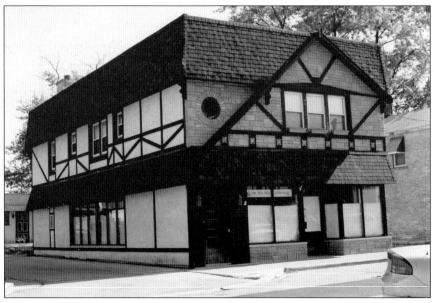

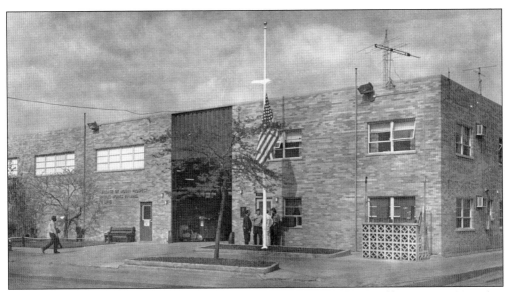

The Mount Prospect Police Department was originally responsible for village maintenance, but by the 1960s, the town had a separate public works department that needed its own building for offices and equipment. Construction was finished at 11 South Pine Street in 1965, and in 1970, the structure was formally dedicated to Howard Wilson, a former Village of Mount Prospect trustee who helped purchase the land for the building. This exterior photograph was taken after 1970.

Although many who grew up in Mount Prospect remember the Pine Street public works building, the department outgrew it by the 1980s. The space had become congested, significantly slowing down operations. A referendum that passed in 1987 approved a new facility at 1700 West Central Road. This photograph of public works director Herb Weeks (left) and deputy director Glen Andler (right) was taken at the ribbon-cutting ceremony on December 3, 1988.

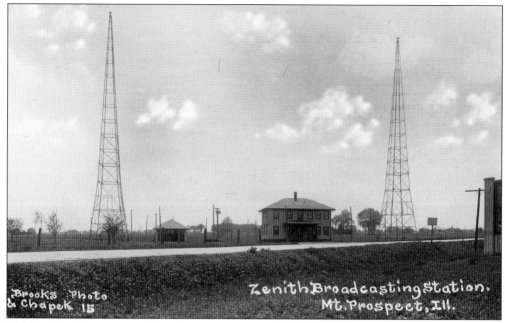

Brooks Photo
& Chapek 15

Zenith Broadcasting Station.
Mt. Prospect, Ill.

The Zenith radio towers and broadcasting station at the intersection of Central, Rand, and Mount Prospect Roads were local landmarks from the time they were installed in 1925 to when they were removed in the 1970s. The Zenith Radio Corporation chose Mount Prospect because it was on high ground and far enough away from Chicago to avoid signal interference. This postcard photograph shows the flat, open surroundings ideal for clear broadcasts. The Zenith station used the WJAZ call letters for only about 10 years, but in 1926, it startled the radio world by using an unoccupied Canadian wavelength to compensate for the limited airtime on its assigned wavelength, which was shared. The US Department of Commerce accused Zenith of pirating wavelengths. WJAZ staff members responded to the legal action with this photograph of themselves dressed as pirates, which they distributed to radio magazines.

Index

Arlington Club Beverage Company Pop Shop, 68
Busse Avenue, 32–34, 124
Busse Realty Association, 123
Central Continental Bakery, 52
Central Plaza, 104, 105
Central School, 13–16
Century Tile, 121
Countryside Bank, 45
Countryside Shopping Center, 45
Dietrich Friedrichs House, 10–13
Evan's Restaurant, 117
Feehanville School, 88, 89
Friedrichs Funeral Home, 65
Gregory School, 66
Gunnell's Restaurant and Bowling Alley, 118
Hapsburg Inn, 120
Hotter Than Mother's Music, 19
Huntington Commons, 102
Illinois Range Company, 101, 102
Jake's Pizza, 54
Keefer's Pharmacy, 79, 122
Kellen's Country Florist, 46
Kruse's Tavern and Restaurant, 20–22
Lions Memorial Park, 57–59
Main Street, 68, 89–91
Meeske's, 51
Mell and Paul's Restaurant, 53
Moehling General Store, 17–20, 72
Mount Prospect Chop Suey, 119
Mount Prospect Fire Station 14, 85, 86
Mount Prospect Municipal Building, 82–84
Mount Prospect Park and Shop/Prospect Place, 78–81
Mount Prospect Plaza, 47–49
Mount Prospect Post Office, 66, 117
Mount Prospect Public Library, 92–94
Mount Prospect Public Works buildings, 125
Mount Prospect State Bank, 110–113
Mount Prospect Train Station, 23–25
Nicholas J. Melas Park, 54–56
Northwest Highway, 69–73

Prospect High School, 67
Randhurst Shopping Center, 40–44
Sammy Skobel's Hot Dogs Plus, 109
Schimming Oil Company, 121
Small Downtown Triangle, 105–109
South Church Community Baptist, 30, 31
St. Emily Catholic Church and School, 62
St. John Lutheran Church and School, 26–29
St. Mark Lutheran Church, 64
St. Paul Lutheran Church and School, 63, 76–78
St. Raymond Catholic Church and School, 61
United Airlines, 114, 115
Uptown Standard Service Station, 96–98
Van Driel's Drug Store, 36
Veterans of Foreign Wars Hall, 49–50
water tower, 25, 73, 121
Wille Lumber and Coal/Hardware Store, 98–100, 108

Discover Thousands of Local History Books Featuring Millions of Vintage Images

Arcadia Publishing, the leading local history publisher in the United States, is committed to making history accessible and meaningful through publishing books that celebrate and preserve the heritage of America's people and places.

Find more books like this at
www.arcadiapublishing.com

Search for your hometown history, your old stomping grounds, and even your favorite sports team.

Consistent with our mission to preserve history on a local level, this book was printed in South Carolina on American-made paper and manufactured entirely in the United States. Products carrying the accredited Forest Stewardship Council (FSC) label are printed on 100 percent FSC-certified paper.